# MORE
# ROYCROFT
# ART METAL
## WITH PRICE GUIDE

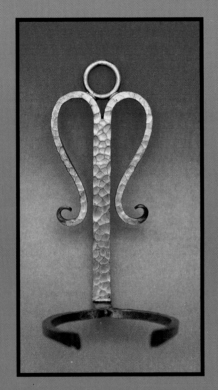

# KEVIN McCONNELL

Schiffer Publishing Ltd

77 Lower Valley Road, Atglen, PA 19310

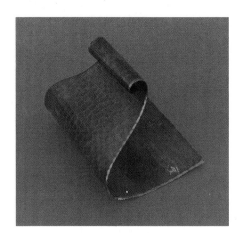

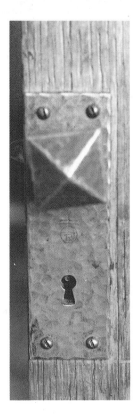

Many pieces of Roycroft furniture incorporate hammered copper accoutrements such as the lock plate shown on the door of this china closet.

Printed in Hong Kong
ISBN: 0-88740-848-6

We are interested in hearing from authors with book ideas on related topics.

Published by Schiffer Publishing Ltd.
77 Lower Valley Road
Atglen, PA  19310
Please write for a free catalog.
This book may be purchased from the publisher.
Please include $2.95 postage.
Try your bookstore first.

# *Acknowledgements*

This second volume on Roycroft art metal is the sixth reference book that I've written and photographed, and it is the end result of hundreds of hours of time and effort. I know that it doesn't look like it could possibly take that long to produce, but believe me when I tell you that there's a great deal of hidden work involved.

There was likewise a lot of hidden help in the making of this book. As is the case with my other books, this one would never have been completed without the assistance of my friends and family. As such, I would like to thank the following people for sharing their time and Roycroft with me....

Debra Blakely, Bruce Bland, Dick Bosworth, Jim Carey, John Edwards, Norman Garrison, David Johns, Julie Kunz, Dan Lopez, Mr. and Mrs. C.H. McConnell, Michael Mee, Robert Wyman Newton, Vera Parry, Matthew and Beverly Robb, Norman Silverman, Carol Stone, Joan Tackel, and last but not least, my girlfriend Anne Walker ("No, Anne, we can't go to the movies tonight, I've got to work on the Roycroft book").

And very special thanks to my eleventh-hour saviors Richard Blacher and David Rago for providing me with photos that were essential to the completion of this book.

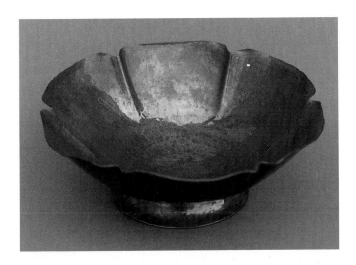

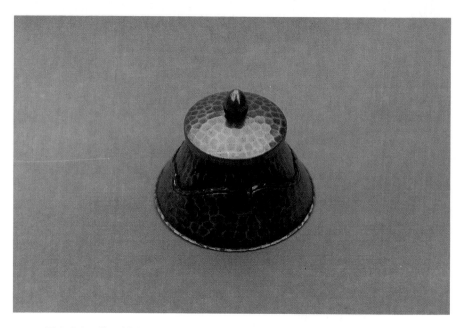

This inkwell exhibits the ingenuity of the Roycroft craftsman. It is actually production inkwell #551 (see Book One, page 78), to which has been applied an additional layer of undulating copper, thus creating a new design.

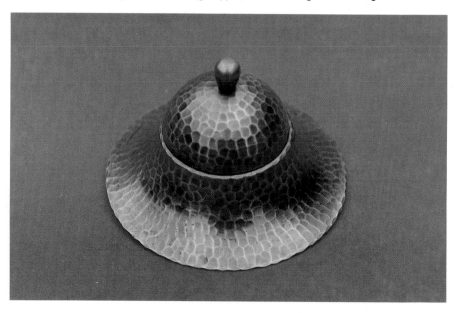

A beautiful and precisely made Roycroft bell-form inkwell with a brass wash. 3" high, 5" basal diameter. Middle mark.
**Production number: 542.**
**Original price: $5 (circa 1925).**
**Current value: $175-$225**

# Contents

DECEMBER NUMBER, 1911    30 Cents

# Fine Arts Journal

DEVOTED TO
THE FINE AND
DECORATIVE
ARTS

HOME
BUILDING
*AND*
ADORNMENT

# Introduction:
# State of the Arts and Crafts

There are several reasons why I have written a second book on Roycroft art metal. One is that since my first book on the subject was published in 1990, Arts and Crafts items in general and Roycroft collectibles in particular have continued to enjoy a growing popularity—so much so that the first volume, *Roycroft Art Metal,* was recently reprinted in a second edition with an updated price guide. This is extremely gratifying for me, since I feel so strongly about both the book and the subject matter.

A second reason is that 1995 marks the one hundredth anniversary of the founding of the Roycroft Campus. It is a cause for celebration, and I wanted to contribute to it by releasing this second volume on Roycroft copper. Speaking of which, I've been working on this second volume on and off for the last two years. For me, it is quite literally a labor of love, and I've gone to great efforts to try to make this book every bit as good as the first volume.

To that end, I've tried to incorporate a variety of aspects and information that wasn't included in the first book, as well as revised and updated material. But what you'll probably enjoy most of all are the dozens of color photos of wrought copper objects, which so clearly depict the lasting skill and ingenuity of the Roycroft craftsmen.

In addition to the photos, you'll find that I've included Roycroft Copper Shop production numbers where I've known them. The Roycroft art metal prices that appear in this book are based upon 1994 values. I have derived these from a variety of sources—auctions, other price guides, antique shops and shows among them.

Believe me when I tell you that 1995 will be a great year for Roycroft collectors everywhere. Enjoy the celebration.

# A Roycroft Timeline

The following is a capsule history of the major events that shaped the Roycroft Campus and Copper Shop.

**1856:** Elbert Hubbard is born in Bloomington, Illinois.

**1895:** Inspired by England's William Morris and the Kelmscott Press, Hubbard founded the Roycroft Printing Shop in East Aurora, New York.

**1899-1902:** Under Hubbard's direction, several other buildings are erected on the Roycroft Campus, including the Roycroft Inn, which opened in 1902.

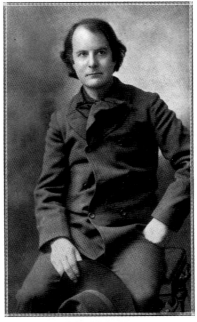

ELBERT HUBBARD
*About the time he started The Roycroft Shops*

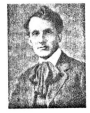

# Why Discriminating People Will Order Roycroft Gifts!

## By Elbert Hubbard II

LBERT HUBBARD, my father, founded the Roycroft Shops twenty-one years ago; founded them on an Idea borrowed from the English Artist-Craftsman, William Morris — to make Books and Things "not How Cheap but How Good!"

❡ When in the Spring of 1915 Elbert Hubbard sailed away on the ill-fated *Lusitania* never to return, he left this Institution and its 500 Workers in my charge.

❡ To hold on to the men of merit and ability who assisted Elbert Hubbard in establishing the Excellence of the Roycroft Mark, has been a particular and pleasant privilege to me. More — I invited back Artists and Workers of Superior Skill, who had left us for a while to Study afield!

A picture and message from Bert Hubbard shortly after he took charge of the Roycroft Campus.

**1906:** Recognizing the sales potential of wrought metal items made for the Roycroft Inn, Hubbard has the Copper Shop built and staffed.

**1908-1909:** Karl Kipp is placed in charge of the fledgling Copper Shop, which prospers under his talented direction.

**1909-1910:** Kipp and fellow Roycrofter Dard Hunter collaborate on numerous Copper Shop designs, involving German silver overlays, square cut-outs, and geometric styling–all reflective of Hunter's recent studies in Vienna.

**1911:** Kipp and his first assistant Walter Jennings quit the Roycroft Copper Shop in order to establish their own Tookay Shop, also located in East Aurora.

**1912:** The Roycrofters receive their greatest commission and subsequently produce approximately 300 ceiling lights, 300 table lamps, 18 large chandeliers, 41 lanterns, and 2900 hand-hammered drawer pulls for the Grove Park Inn of Asheville, North Carolina.

**1915:** Elbert Hubbard and his wife Alice lose their lives aboard the *S.S. Lusitania* on May 7. The Roycroft Campus is consequently overseen by Hubbard's son Bert, whose first business decisions involve requesting the return of Kipp and Jennings to the Copper Shop, and implementing a nationwide distribution and sales policy of Roycroft items.

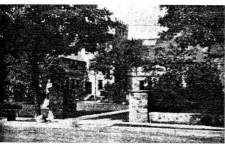

THE MAIN SHOP

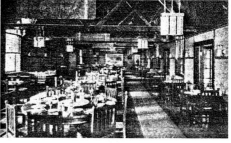

THE DINING-ROOM

THE CHAPEL

THE BINDERY

Various views of the Roycroft Campus as it appeared in 1916.

**1929:** The Stock Market Crash and resultant Depression occur, of which the Roycrofters are eventual victims.

**1931:** Karl Kipp retires from the Roycroft Copper Shop.

**1933:** Walter Jennings also retires from the Copper Shop.

**1938:** The Roycroft Shops declare formal bankruptcy and close down.

# Roycroft Marks:
# A Further Discussion

In the 1990 edition of *Roycroft Art Metal,* I attempted to come up with approximate dating brackets for the various marks utilized at the Roycroft Copper Shop during their 1906 to 1938 production period. Since that time, I've learned a great deal more about Roycroft copper and its markings, and have constructed the following chronological sequence of Roycroft shopmarks...

**Preliminary Mark**
(circa 1906-1909)

As shown below, this earliest of the orb and cross marks is of awkward, elongated proportions. Although rarely encountered, it tends to be found on items exhibiting both simple design and crude workmanship, such as ashtrays, pen trays, and letter openers. These pieces are the forerunners of the more familiar Roycroft production pieces which made their debut in 1909/1910.

### Early Mark
(circa 1909-1915)

Under the talented direction of Master-Craftsman Karl Kipp, the Roycroft Copper Shop reached viable commercial production and released their first catalog of available copperwares in 1909/1910. These items included a wonderful and distinctive array of lamps, bookends, desk items, vases, and much more, all of which bear the early mark shown below. Note the curled tail on the R which is distinctive of this mark.

This early mark continued to be utilized by the Roycrofters for several years, including on the chandeliers and various other copper items made for the Grove Park Inn, which date from the 1912/1913 period.

### Middle Period Mark
(circa 1915-1925)

As shown here, the middle period mark differs from its earlier counterpart in that the tail of the R is straight rather than curled.

It is my feeling that the Roycrofters began employing this modified mark in 1915. As we know, 1915 was a year of great change on the Roycroft Campus—Elbert Hubbard perished aboard the *S.S. Lusitania*, his son Bert assumed leadership of the business, and Karl Kipp returned to his position as Master-Craftsman of the Copper Shop. Given this combination of crucial events, I believe it is logical to speculate that the Roycroft mark was changed in 1915; it signaled the end of one era and the beginning of another.

Additionally, copper items shown in the Roycrofters 1916 catalog are largely new designs which bear this middle period shopmark. This mark appears to have been utilized up until circa 1925 when new Roycroft copper designs appeared along with a new mark.

## Late Mark
(circa 1925-1938)

The Roycrofters released one of their last major production catalogs in 1925. Entitled "The Book of the Copper Shop," it featured a new line of wrought copper items and designs, these typically being made from a heavy gauge of brass-washed copper. The items that appear in this catalog bear a new shopmark– the familiar orb and cross mark with the word "ROYCROFT" added below it. This was the final mark the Roycrofters used, employing it up until the Copper Shop closed in 1938.

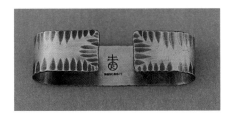

## Late Mark Variant
(circa 1925-1938)

The Roycrofters produced a line of silver-plated copper items which they marketed under the name of Modern Sheffield. Many of these pieces are marked as shown here, with the orb and cross as well as the words "ROYCROFT SHEFFIELD."

## Modern Mark
(1976-present)

Talented modern day craftsmen working under the name of "Roycroft Renaissance" produce items in hammered copper and wrought sterling silver. Such items can be identified by the contemporary mark which features a double R within the orb and cross.

# Roycroft Patinas and Finishes: Additional Observations and Information

The Roycrofters employed a variety of finishes on their copperware, including their Modern Sheffield line which was silver or nickel silver plating over copper, Old Brass which was brass plating over copper, and Aurora Brown which involved chemically patinating the copper a darker color through the use of ammonia fumes.

A fourth, much rarer finish utilized by the Roycrofters was a beautiful verdigris patina known as their Etruscan line. Although rarely seen, it has been documented on middle and late period Roycroft copper pieces. The scarcity of examples exhibiting the Etruscan finish would suggest that it was an experimental patina that was tried out for a short time at the Copper Shop in the mid-'20s.

Another technique that must be discussed is heat patination. Although uncommon, heat patinas occasionally can be seen on circa 1910 Roycroft copper items. In all likelihood, this technique was probably employed before the more familiar Aurora Brown chemical patina was perfected at the Copper Shop. Heat patinas were achieved pretty much as one might expect–the finished copper piece was exposed to the flames and heat for a period of time, resulting in a crusty, reddish-greenish-brown finish.

With all of the above to choose from, most Roycroft art metal collectors prefer those items with an Aurora Brown finish. Arguably, such pieces highlight the natural beauty of the copper, as opposed to the silver and brass plated examples which seek to emulate other metals. For the most part it is felt that Aurora Brown Roycroft copper has a warmth and quality to it that the other finishes lack, and that it blends better with arts and crafts surroundings.

Even so, there are various counter-arguments for collecting Roycroft copper in a variety of finishes. One is that the different finishes add some color and diversity to an otherwise very brown collection. Two is affordability; since Roycroft with brass or silver plating has a smaller audience, it can often be acquired at a

reasonable price. The third and most important consideration is that of rarity. Many Roycroft art metal pieces are so scarce that if a collector passes by Modern Sheffield or Old Brass examples of, say, a hat pin or a desk clock, they run the risk of never acquiring those pieces for their collection in Aurora Brown.

In the end, it is not the color of the finish that matters nearly as much as the *condition* of that finish. Collectors should strive towards acquiring unpolished examples in as close to mint condition as possible. Repatinated items are certainly worthy of consideration if the piece is rare and if the price is right.

Interestingly, the Aurora Brown finish can be found in a variety of shades, ranging from a light reddish honey brown to a dark chocolate brown. Again, it is not the shade that matters nearly as much as the condition of the patina.

In closing, I have worked out the following system of evaluation for Roycroft copper items, with Aurora Brown examples holding the position of median price. For example, a pair of Roycroft bookends in near mint condition with an Aurora Brown finish are valued at $150. The same bookends are evaluated accordingly, taking the following facts into consideration...

*With a polished or damaged patina:* 40-50% less.
*With a slightly worn finish:* 15-20% less.
*With a silver, brass, or repatinated finish:* 20-25% less.
*With a heat patina or Etruscan finish:* 30-40% more.

A final decorative aspect that needs to be factored into our evaluation formula is Italian Polychrome decoration. This includes that line of early and middle period Roycroft copper which was highlighted with green and/or orangish-red enamelling. This pleasing Roycroft decoration is loosely credited to Walter Jennings, and examples exhibiting it are worth approximately 20% more than pieces lacking such enamelling.

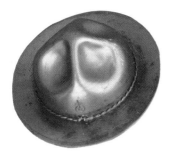

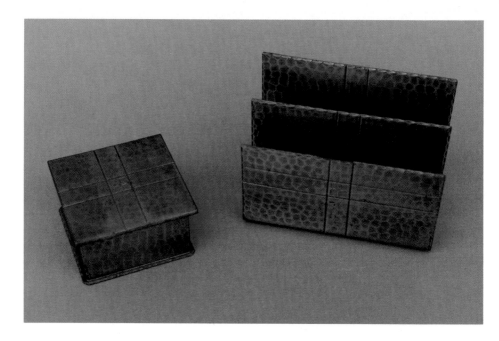

A two-piece desk set comprised of an inkwell (1.5" high, 3" square) and a letter rack (3.5" high, 4.5" long, 2.25" wide). Both exhibit exceptional design and workmanship. Of particular interest is the presence of Italian Polychrome enamelling on these items.
**Current value: $175-250/set.**

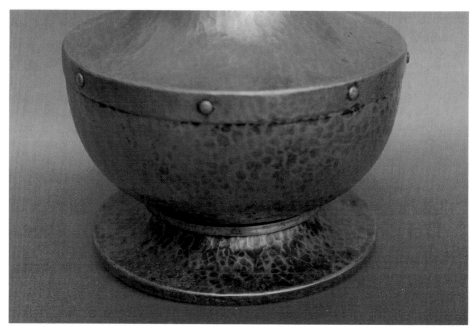

Close-up of a heat patina, showing the resultant reddish green crusty finish.

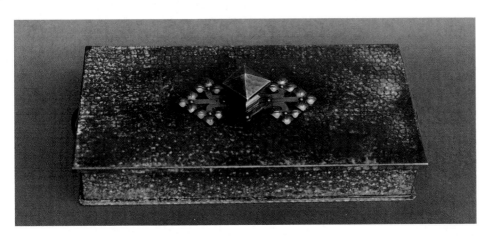

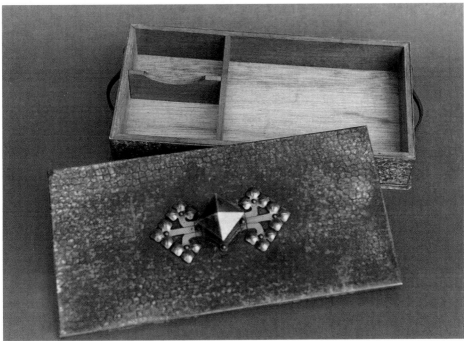

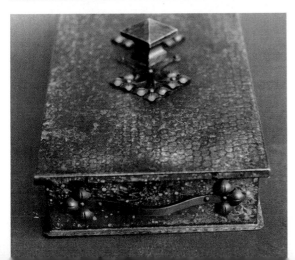

Three views of an extremely unusual Roycroft box. Green patinated pieces such as this one were part of Roycroft's rarely seen Etruscan line. Note the flawless workmanship design, and patina. Middle mark.
**Current value: $1500-$2000.**

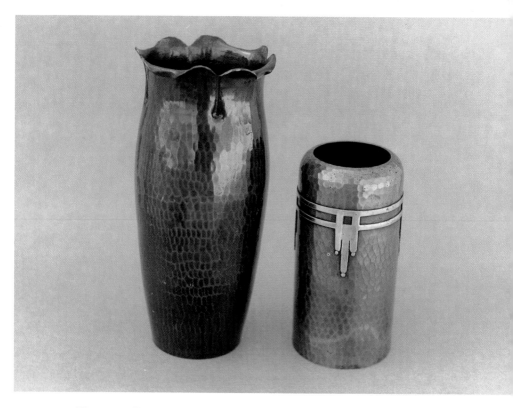

These two Roycroft vases clearly depict the great range of coloration to be found in the Aurora Brown finish.

The three main finishes utilized at the Roycroft Copper Shop. From left to right: Old Brass, Modern Sheffield, and Aurora Brown.

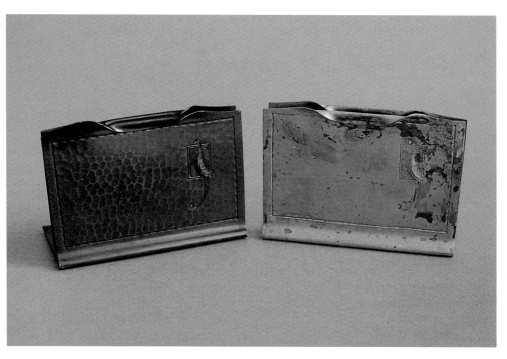

This picture is worth the proverbial thousand words in respect to the importance and condition of original patinas.

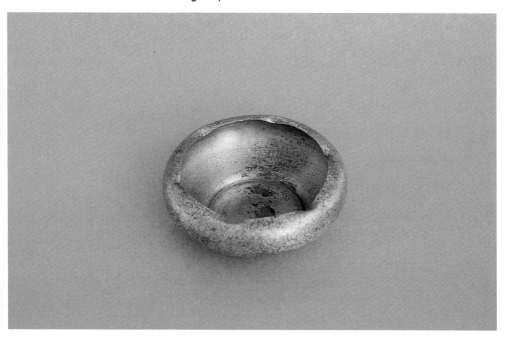

As this picture attests, there are few things uglier or less desirable than a badly worn Modern Sheffield finish.

# Evaluating Workmanship on Roycroft Copper

Whether it is an early, middle, or late period example of Roycroft copper, each piece must be judged individually on the merits of its own design, quality of workmanship, and patina—or lack thereof.

In general, Roycroft's early work (circa 1909 to 1915) is by far its best. In terms of design, the seminal efforts of the Copper Shop are a kaleidoscope of form and function blended with the aesthetics of Art Nouveau, the Vienna Secessionists, and the Arts and Crafts Movement. The result is beauty and strength of design which adapts and incorporates everything from rivets to floriforms, synthesizing them into a style which is uniquely Roycroft's own.

The workmanship of the Roycroft Copper Shop's early pieces is much more individualistic and idiosyncratic than that which would come later. These early examples possess a charming crudeness and irregularity which represent both the hand of the struggling artisan and the very heart and soul of the Arts and Crafts philosophy.

Towards the other end of the production spectrum is Roycroft's circa 1925 copperwork. Typically made from a heavy gauge of brass-plated copper, this line represents Roycroft's last attempt at quality workmanship—"attempt" being the key word here.

While these 1925 pieces represent good journeyman work, the hammering tends to have an almost mechanical, production-line sameness to it. Most of the designs are clunky and heavy-handed, and/or evince Art Deco styling rather than that of Arts and Crafts.

In brief, 1925 was a watershed year at the Roycroft Copper Shop. They were doing whatever was necessary to stay in business, but in doing so they were abandoning the ethics of the Arts and Crafts Movement.

As a rule of thumb, the later Roycroft copper was made, the less interesting it is—and there is nothing much less interesting than Roycroft's post-Depression output. At this point in time, the hand of the artisan is gone and what was being made were

simple spun copper forms that are altogether lacking in design, workmanship, and even patina. Some examples have acid-textured surfaces, this being an attempt to create the illusion of hand-workmanship. As one might imagine, these post-Depression pieces are of little or no interest to serious Roycroft collectors.

It has been my experience that one is better off spending too much on an early example of Roycroft copper than buying a multitude of late or mediocre pieces. Where Roycroft is concerned, quality and rarity are key factors in building your collection.

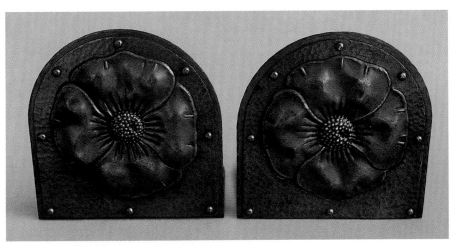

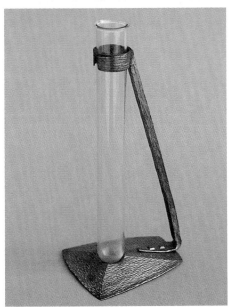

The series of photographs on the next several pages shows the eventual decline of Roycroft copper design and workmanship. The items on this page are circa 1910; the items on page 22 are mid-period items dating from circa 1916; the items on page 23 are circa 1925 copperwork; and the items shown on pages 24-25 are typical of post-Depression workmanship.

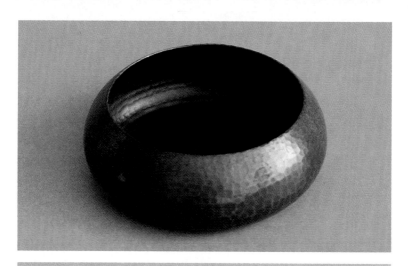

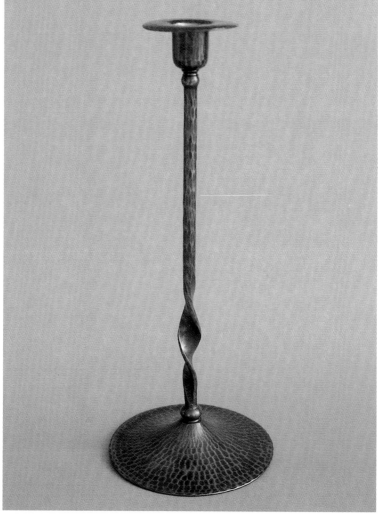

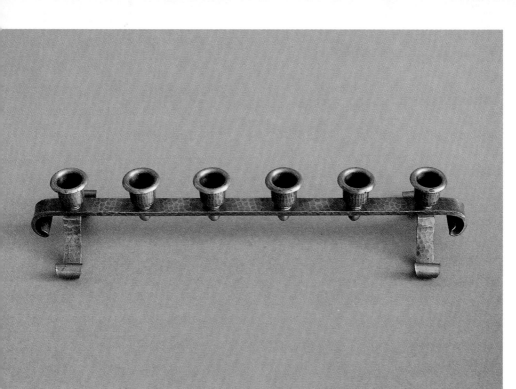

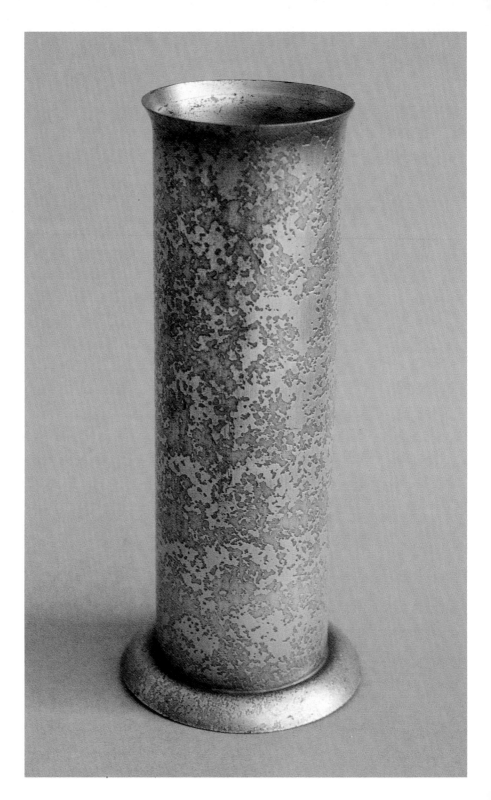

# The New and Improved Roycroft Art Metal Rarity Chart

What I've attempted to do here is construct a very specific and detailed rarity chart. I have assigned numerical rarity ratings of one through ten, and have tried to fill out these categories by mostly utilizing examples that appear in this book and in volume one.

When considering the rarity and value of Roycroft items, it is important to remember that not everything that was produced at the Roycroft Copper Shop was wonderful. Some of it was plain and simply of inferior quality, particularly their post-Depression output.

Also, while some Roycroft items are extremely well made and beautifully designed (for instance, the rounded owl motif book-ends), they remained in production for ten to fifteen years and are therefore quite common. However, there are other items (such as the desk clock or humidor with nickel-silver squares) which were only made for a year or two and are consequently much rarer and more valuable.

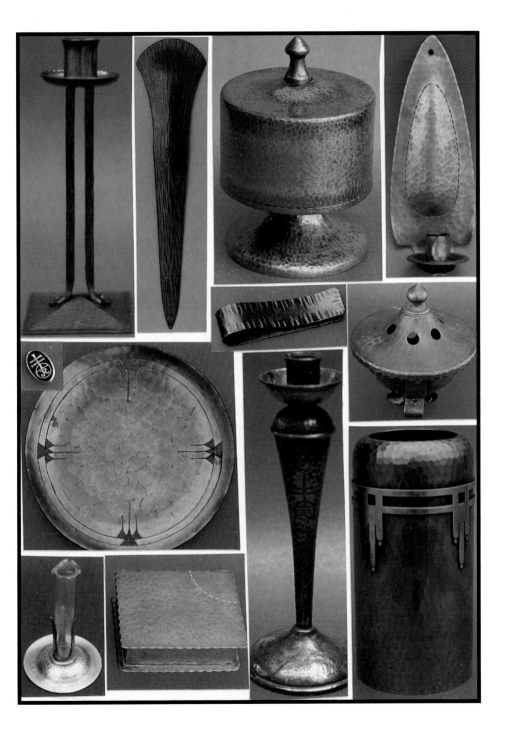

Confused and confounded over questions of rarity? Consult the Roycroft Rarity Chart.

# RAREST

**Rarity: 10**
Humidor with nickel-silver squares, Roycroft-K. Kipp stein, coffee pot, jardinieres, items with square cut-outs, chandeliers and electroliers.

**Rarity: 9**
Desk clock, jewelry, buttress vases, chafing dish, cylinder vase with conventionalized rose motif, shaft vase, large table lamps with slag glass or mica shades.

# RARE

**Rarity: 8**
Items with Etruscan finish, hat pin, table lamps with Steuben glass shades, large vases (such as #213).

**Rarity: 7**
Cylinder vase with nickel-silver band, boxes, items with heat patinas, 10" vase with diamond-shaped floral band and tooled vertical stems (#212).

# SCARCE

**Rarity: 6**
Smoking stand, American Beauty vase, table lamp with domed shade, 6" vase with Steuben 'Bubbly' insert, three-footed nut or fruit bowl, poker chip caddy, complete smoking sets.

**Rarity: 5**
Door knocker, twist-stem candlesticks and candelabra, table lamp with Steuben Aurene body, tea-bell, incense burners, picture frames, items with Italian Polychrome finish.

# COMMON

**Rarity: 4**
Poppy bookends, Princess candlesticks, complete desk sets, wall sconces, double and triple inkwells, bookends with riveted construction.

**Rarity: 3**
Serving trays, bud vases, small boxes and vases, two-branch candlesticks, owl or peacock motif bookends.

# VERY COMMON

**Rarity: 2**
Napkin rings, simple candlesticks, card trays, matchbox holders, chambersticks.

**Rarity: 1**
Crumber sets, ashtrays, simple desk items, acid-etched and spun copper items, most bookends.

# The Roycroft Connection-History

## The Grove Park Inn

The largest assemblage of Roycroft lighting is not to be found in East Aurora, but instead at the Grove Park Inn in Asheville, North Carolina. It is part of the Roycrofters' greatest commission.

During the period of 1912-1913, the Grove Park Inn was designed by Fred Seely, and the construction of it was financed by Edwin Grove. During this time, Seely, a long-time friend of Elbert Hubbard's, commissioned approximately $25,000 worth of products from the Roycrofters.

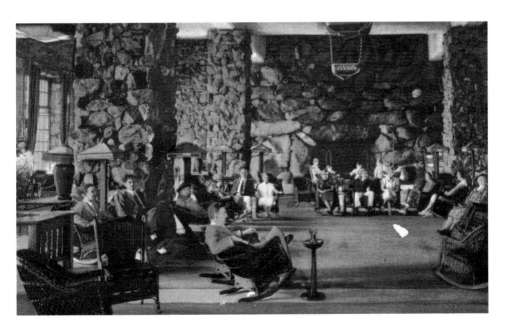

A period postcard showing the Grove Park Inn lobby. Note the massive Roycroft chandelier in the upper background and the Roycroft smoking stand in the lower foreground.

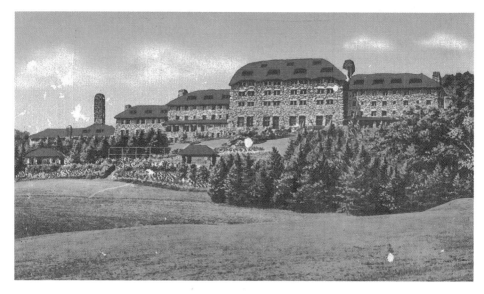

A period view of the Grove Park Inn, which houses the Roycrofters' greatest commission.

Although this included over four hundred pieces of furniture for the Inn's dining room, the burden of the commission fell upon the Roycroft Copper Shop. In the space of twelve months, the men of the Copper Shop succeeded in the back-breaking task of producing some 41 lanterns, 18 large chandeliers, 24 American Beauty vases (22"), 300 table lamps, 300 ceiling lights, and 2900 hammered copper drawer pulls.

The latter were made for use on pieces of bedroom furniture for the Inn, which were built by the White Furniture Company of Mebane, North Carolina. This odd and unique hybrid of Roycroft and White resulted from the small Roycroft furniture shop's inability to produce the staggering 1500+ pieces of bedroom furniture that Seely required in the space of a year.

Although the Grove Park Inn commission was fortuitous for the Roycrofters, it was also somewhat ill-timed. The commission came shortly after Roycroft Copper Shop Master-Craftsman Karl Kipp and his first assistant Walter Jennings quit to found their Tookay Shop.

With the two most important and skilled metalsmiths gone from the Copper Shop, it has long remained a mystery as to who actually stepped in to design and supervise the Roycrofters' metalwork for the Grove Park Inn. Thanks to research done by Elbert Hubbard Museum curator Bruce Bland, we now know that it was designer/illustrator Victor Toothaker who filled the void at the Roycroft Copper Shop left by Kipp and Jennings.

Much of what the Roycrofters made for the Grove Park Inn is still there to be seen, used, and enjoyed by their guests. Probably the best time to do so is during the third weekend in February, when the Inn hosts the annual Arts & Crafts Conference & Antiques Show.

## Karl Kipp and the Tookay Shop

Not enough can be said about Karl Kipp. In his role as Master Craftsman of the Roycroft Copper Shop, he was the consummate artisan, designer, and overseer. The commercial success of the incipient Copper Shop can by and large be attributed to Kipp's skill and efforts. This is particularly amazing when one considers that Kipp was an ex-banker with no formal training whatsoever in copperwork.

Elbert Hubbard possessed the ability to recognize the potential in his Roycrofters, and he chose well when he placed Kipp in charge of the Copper Shop in 1908/1909. At the time, Hubbard had no way of knowing that Kipp would leave his employ in 1911, taking his first assistant, Walter Jennings, with him.

Relocating a few blocks away on Church Street in East Aurora, Kipp founded his own coppersmithing enterprise, the Tookay Shop. Exactly why Kipp quit the Roycroft Copper Shop remains a matter of conjecture, but the simplest conclusion to draw is that it was a business decision on his part.

By 1912, the Tookay Shop was very much a reality. Kipp and Jennings had designed a full line of art metal wares, ads for which began to appear in *Craftsman* magazine, as well as in their own Tookay catalog which was published that year.

The enterprise appears to have been reasonably successful, as a second, larger Tookay product catalog was released in 1914. During this time the Tookay Shop operated a showroom on Main Street in East Aurora, and also briefly maintained a display and sales room in New York City.

The Tookay Shop product line was a mixed bag, consisting of designs that Kipp created for the Roycroft Copper Shop, such as the Princess candlesticks, the buttress vase, the handled bud vase, and various desk and smoking-related items. But beyond these familiar forms, Kipp also devised a multitude of stunning items which are unique to the Tookay Shop.

Among these are a 7" high handled pitcher, a great variety of wrought sterling jewelry, spectacular copper and leaded slag glass tables and hanging lighting, jewelry boxes, wall sconces, a fern dish with an embossed mushroom design, and a plethora of bowls, vases, trays, and desk pieces.

Kipp differentiated his Tookay work from that of the Roycrofters with a simple but distinctive impressed mark—his initials KK (the first one being reversed) enclosed within an orb. The first of two marks that he used, it is found exclusively on Tookay wrought copper and sterling items (see photo).

Although the Tookay Shop was always a small operation, photos from the period show several other men hard at work besides Kipp and Jennings. It's likely that Kipp gleaned these workers from the Roycroft Copper Shop or perhaps from the School of Handicraft which he and former fellow Roycrofter Dard Hunter directed in East Aurora.

In 1915, the unthinkable occurred; Elbert Hubbard died aboard the Lusitania, leaving the Roycroft Shops in the hands of his eldest son, Bert. But they soon proved to be capable hands, as Bert quickly convinced Kipp and Jennings to return to the Roycroft Copper Shop in 1915.

There is evidence that Kipp continued to operate this Tookay Shop in some capacity into the 1920s, at which time he specialized in various Art Deco-oriented wrought pewter designs. A revised circle and hammer mark is found on Kipp's Tookay pewter work (see photo).

Exactly when the Tookay Shop closed is unknown, but certainly it ceased to exist by the time of the Great Depression. We do know that Kipp retired from the Roycroft Copper Shop in circa 1931, eventually moving to Olean, New York, where he became head designer for a metal furniture fabricator named the Daystrom Corporation.

Kipp died in Olean in 1954 at the age of 73, leaving behind him an enduring legacy of quality workmanship.

KARL KIPP " *Kippy* "
Master Craftsman

Karl Kipp as he appeared circa 1925.

The early Tookay mark which is found on wrought copper and sterling items.

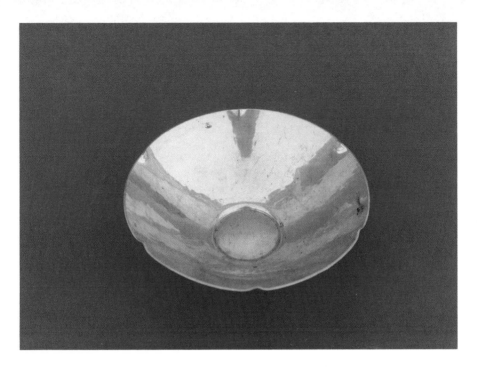

A finely hammered Karl Kipp/Tookay Shop pewter bowl with crimped rim. 2" high, 7" diameter.
**Current value: $250-$300.**

An example of the later or second mark which is found on all wrought pewter from the Tookay Shop.

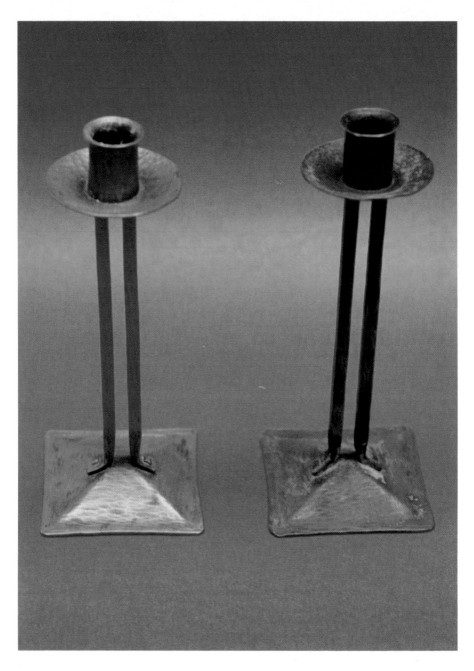

Karl Kipp made his own line of Princess candlesticks at his Tookay Shop, leaving no doubt as to who designed them for Roycroft. Although quite similar to their Roycroft counterparts, these Kipp candlesticks have rounded base corners and less of a production line appearance. Like most Kipp copper wares, these pieces are simply marked with a back-to-back 'K' symbol.
**Current value: $500-$600/pair.**

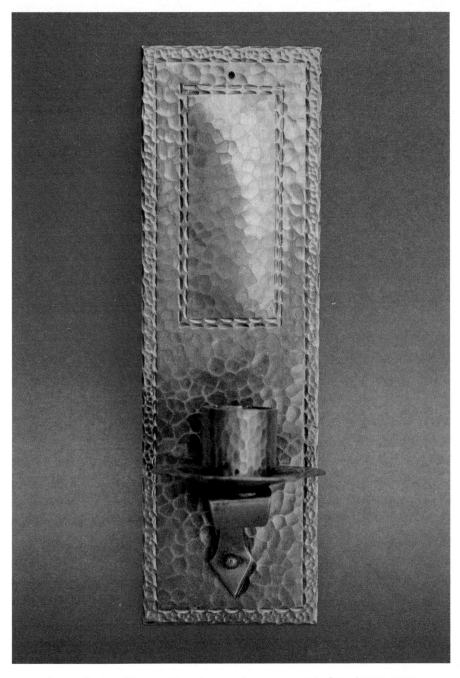

A rare Tookay Shop wall-hanging candle sconce made from heavy-gauge copper. Observe the crisp, precise hammering, particularly on the edge of the backplate. This sconce measures 10" high by 3.25" wide. Early Tookay mark.
**Original price: $3 (circa 1914).**
**Current value: $225-$275.**

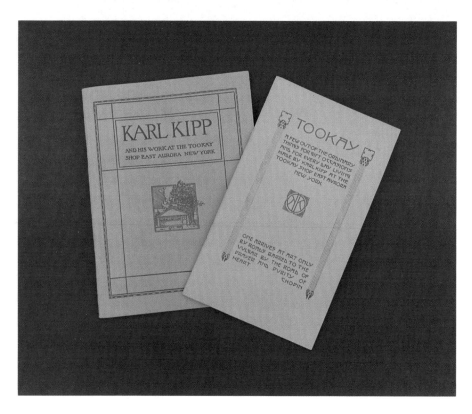

These Tookay Shop catalogs have been reprinted and provide valuable insight and information on Kipp's work.

*Opposite page:*

The incredibly rare Roycroft stein made of hammered copper, sterling silver, and jade. It is a masterpiece of design and workmanship, clearly displaying Kipp's style circa 1910, when he was strongly influenced by Dard Hunter and the Vienna Secessionists. The stein is 6" high and 4.5" in diameter. Also shown is the bottom of the stein, which displays the rarest combination of marks—Roycroft and Karl Kipp. Since the stein was a Roycroft production piece, we can assume that it was made by Kipp himself and thus bears his personal mark in addition to the orb and cross symbol.

This combination of marks has also been observed on Tookay production pieces, which were probably purchased from Kipp by Elbert Hubbard and then marked and sold as Roycroft products. Tookay copper items can be found advertised as Roycroft wares in the November 1911 *Fra* magazine.

**Original price: $25 (circa 1910).**

**Current value: $3000-$4000+.**

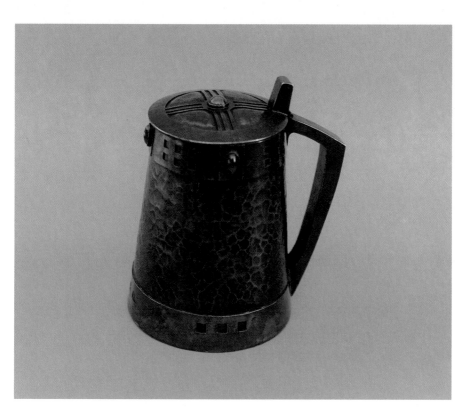

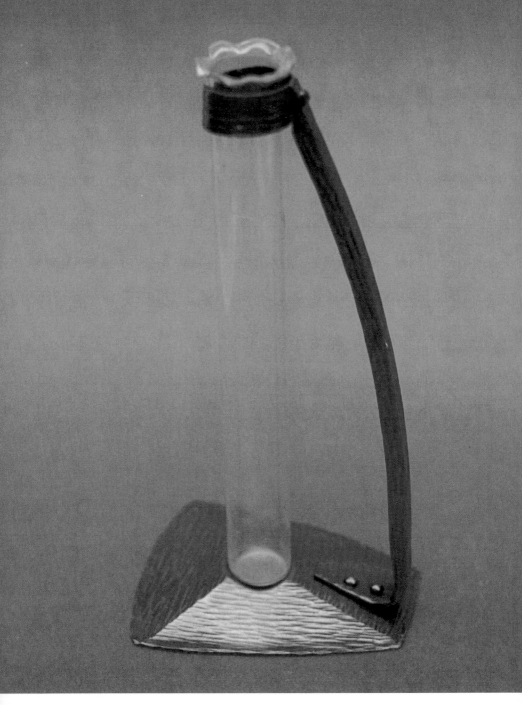

This bud vase, the design of which is so strongly associated with Karl Kipp, was made by him and his co-workers at the Roycroft Copper Shop as well as his own Tookay Shop. 8.5" high.
**Original price: $2 (circa 1914).**
**Current value: $300-$400.**

# The Avon Coppersmith

A good Roycroft-related collectible is art copper which bears the shopmark of "The Avon Coppersmith." Located in Avon, New York, this shop was established by former Roycroft coppersmith Arthur Cole. Judging from the gauge of the material and from the style and quality of the workmanship, it seems likely that Cole founded the Avon Coppersmith shop in the late 1920s/early 1930s timeframe; it remained a viable enterprise until circa 1940.

In 1933 Cole was joined in his work by another former Roycrofter—Walter Jennings. Having left the Roycroft Copper Shop for good, Jennings worked with Cole at the Avon shop until around 1940, at which time he returned to East Aurora to begin his own copper shop.

Some of the items made by Cole and Jennings at the Avon Coppersmith shop include: bowls, wall-hanging plant holders, chambersticks, bookends, ashtrays, nut dishes, trays, plates, and vases. Judging their work as a whole, nothing complex or innovative seems to have been attempted, as all examples are simple spun copper or flat-formed pieces.

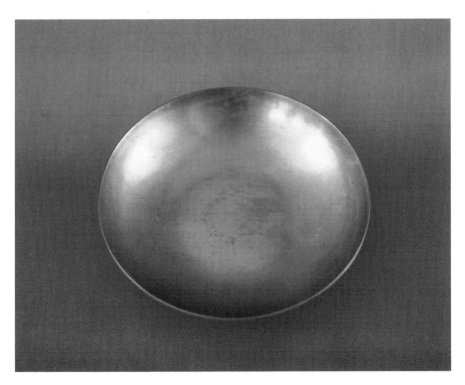

An Avon Coppersmith spun copper bowl measuring 1.75" high and 9" in diameter. Note the absence of hand-hammering and the poor patina.
**Value: $40-$55.**

Overall, most of their output consists of decent journeyman work, the best examples of which imitate Roycroft production shapes. However, some pieces of Avon art copper are of decidedly poor quality, these being items which exhibit no hammering and poor patinas.

Some of the better examples of Avon copperwork make for an interesting addition to one's collection of Roycroft art metal. Since many people are unaware of the origins and associations of Avon copper, it can still be located at very reasonable prices. The 10" hammered copper plate shown in this section was recently purchased at a shop in New York State for $6.

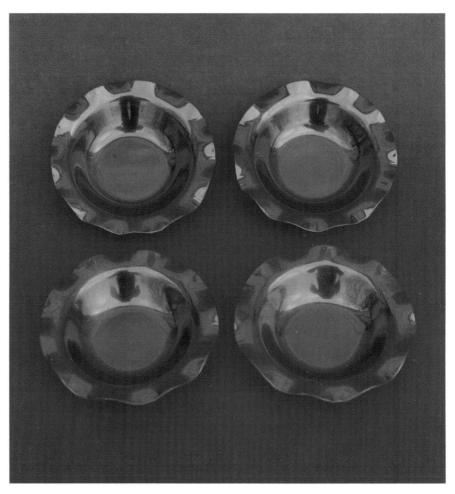

A set of four Avon Coppersmith nut or candy dishes measuring .5" high and 3.25" in diameter. These are made from spun, unpatinated copper with a heavy lacquer finish. The crimped edges are the only evidence of hand-tooling.
**Current value: $25-$35/set.**

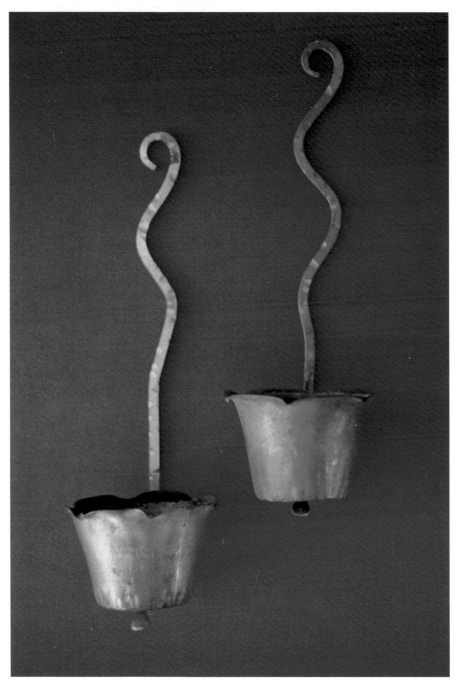

A pair of 12" long wall-hanging flower pots made by the Avon Coppersmith. The backplates consist of square curvilinear pieces of copper embellished with broad hand-hammering, while the attached flower pots have crimped rims and bear wide planishing marks.
**Value: $60-$80/pair.**

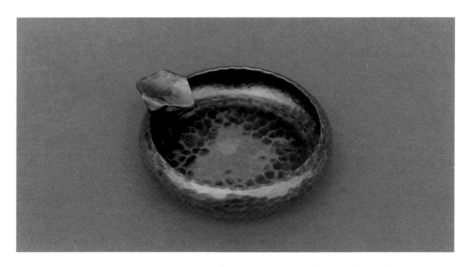

An Avon Coppersmith hammered copper ashtray with attached cigarette rest. It is 1" high and 3.5" in diameter. This ashtray is very similar to one made at the Roycroft Copper Shop, which is designated as production no. 623. **Current value: $35-$45**

A 12" diameter tray made by the Avon Coppersmith with broad hammer marks, a recessed interior and crimped edging. **Current value: $80-$110.**

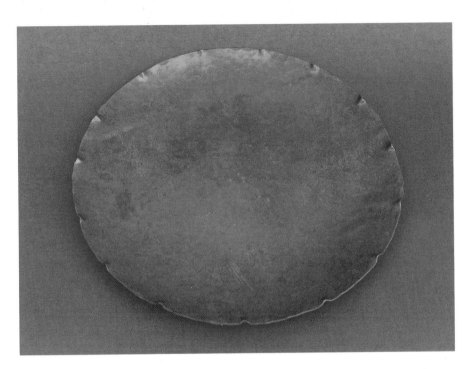

A 10" diameter Avon Coppersmith plate or tray made from a heavy gauge of copper. This is a fine example of their work, reflecting good workmanship and patina.
**Current value: $60-$90.**

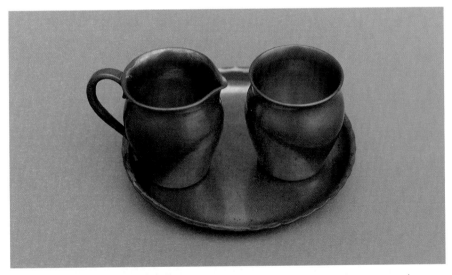

A miniature three-piece Avon Coppersmith sugar, creamer and tray set made from spun copper. The creamer and sugar are each 2.25" high and the tray is 4.5" in diameter. These items evidence little hand-workmanship, except for the tray which has a hammered edge.
**Current value: $30-$50/set.**

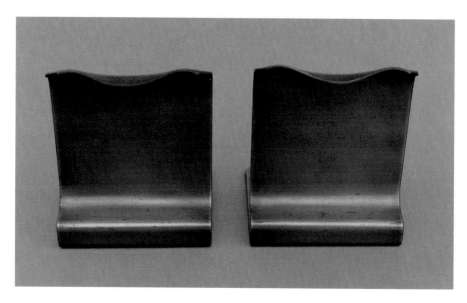

A pair of Avon Coppersmith bookends made from thick, flat copper stock which was cut and formed into shape, 4" high, 3.75" wide.
**Current value: $50-$65/pair.**

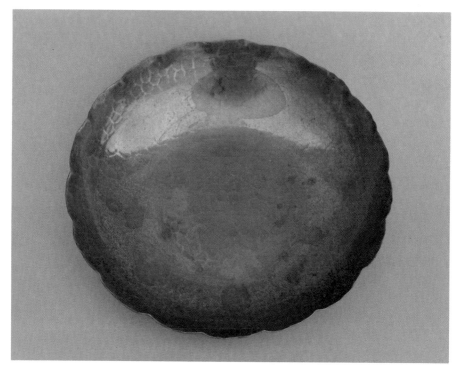

A handsome Avon Coppersmith wrought copper bowl with a dark brown patina and broad, precise hammer marks. 2" high, 9.25" in diameter.
**Current value: $90-$125.**

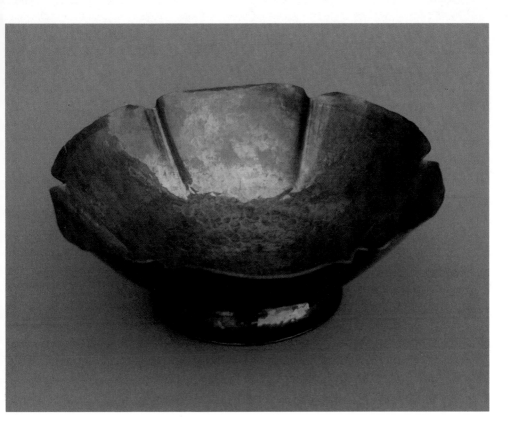

A floriform fruit or nut bowl representing some of the Avon Coppersmith's best design and workmanship. This bowl is 2.75" high and 7.25" in diameter. **Current value: $110-$140.**

Shown here is the standard die-stamped Avon Coppersmith shopmark.

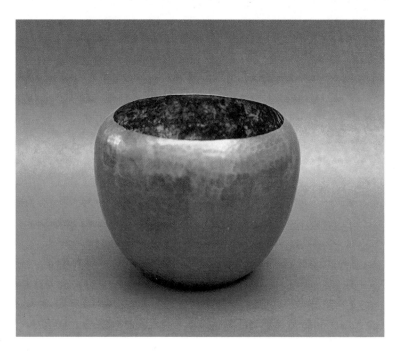

A bulbous Avon Coppersmith vase reminiscent of Roycroft design and workmanship. 4.5" high, 6" greatest diameter.
**Current value: $100-$135.**

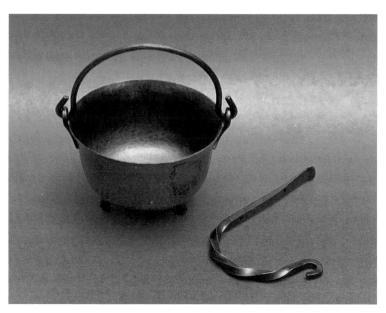

An Avon Coppersmith hammered copper kettle with tripod legs, bail handle, and matching wall bracket. The Roycrofters made a similar item. The kettle is 6" overall height and the bracket is 5.5" long.
**Current value: $85-$120.**

# Roycroft Art Metal Photos and Descriptions

## Bookends

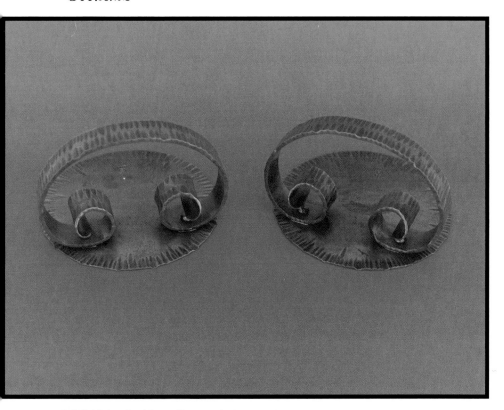

3.25" high, 5" wide curlicue style bookends made from a heavy gauge of brass-plated copper. Observe the broad, radial hammering and the riveted construction. Late mark. Although these are late production pieces, they continue to reflect exceptional workmanship, design, and materials.
**Production number: 368.**
**Original price: $7.50 (circa 1925).**
**Current value: $175-$225/pair**

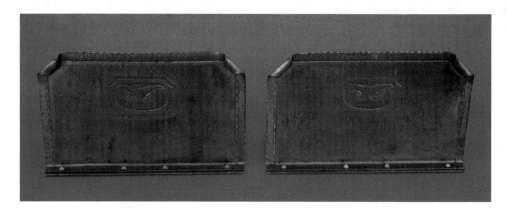

A pair of 4" high, 6.5" wide rectangular bookends which are characterized by folded corners, riveted base construction, and a tooled owl motif within a stippled polychromed reserve. Early mark.

It's notable that these particular bookends are rarer and more difficult to find than the round owl bookends shown on page 41 of *Roycroft Art Metal,* Book One.

**Production number: 321.**
**Original price: $4/pair (circa 1910).**
**Current value: $175-$225/pair.**

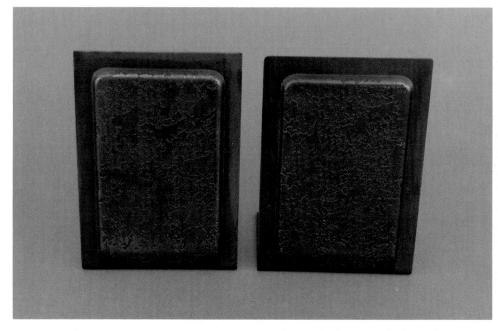

5.25" high, 3.5" wide late line bookends with a raised, acid-etched panel. They are made from a very thin gauge of copper and have a poor, uneven patina. The low quality of these bookends would indicate that they were made towards the end of the Roycroft Copper Shop production period; probably the 1935 to 1938 era. Late mark.
**Current value: $50-$65.**

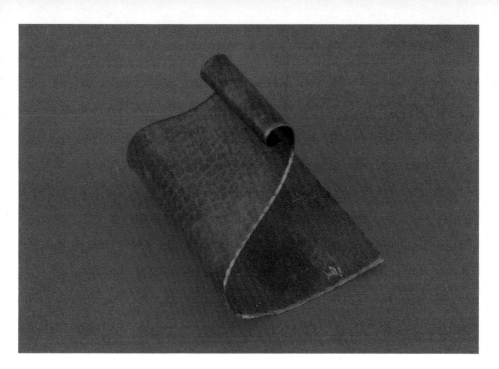

A 4" high S-form bookend with good hammering, dark patina and tooled edges. Middle mark.
**Original price: $2.20/pair.**
**Current value: $95-$140/pair.**

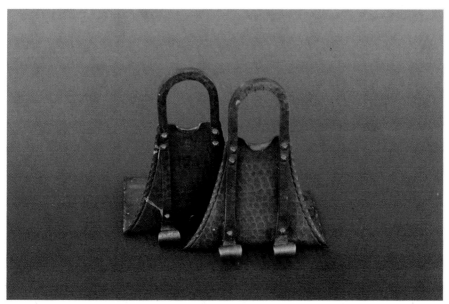

Roycroft bookends consisting of inverted U-forms with scrolled feet riveted to tooled backplates. These display strong Arts and Crafts design and exemplary workmanship. Middle mark.
**Current value: $150-$210/pair.**

A pair of early and particularly rare bookends, which incorporate 'stitched' tooling, rivets, and Italian polychrome decoration. Note that the seemingly geometric designs are actually repeating pairs of the letter 'K', which are the initials of the designer–Karl Kipp. 4" high by 6.5" wide. Early mark. (Collection of Richard Blacher).
**Current value: $600-$750/pair.**

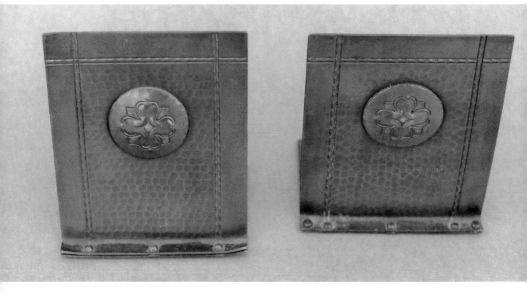

A pair of well designed bookends with riveted bases, decorative stitching, and an embossed central medallion with a tooled floral motif. Middle mark.
**Current value: $225-$275.**

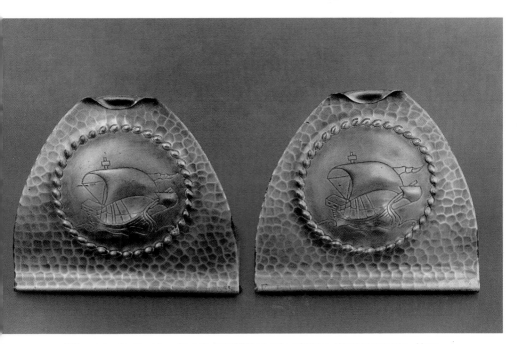

Triangular bookends with a tooled Viking ship within a circular reserve. Note the clean, precise workmanship. 5" high, 5.5" wide. Middle mark.
**Production number: 364.**
**Original price: $9 (circa 1925).**
**Current value: $200-$250.**

One of the Roycrofters' more interesting and innovative efforts during the 1920s was a series of bookends which combined hammered copper with tooled and polychromed leather. Shown here are five of the seven designs they made: Tragedy and Comedy (production #362, originally $6/pair), Elephant design (production #371, originally $5/pair), cover design from Elbert Hubbard's book *Pig Pen Pete*, Viking ship design (production #364, originally $9/pair), and the Owl design (production #361, originally $5/pair). Not shown are a classical figure design and Hans and Gretchen. Bookends shown are each 4.5"-5" high by 4"-4.5" wide. (Collection of Richard Blacher).
**Current value: $250-$350/pair.**

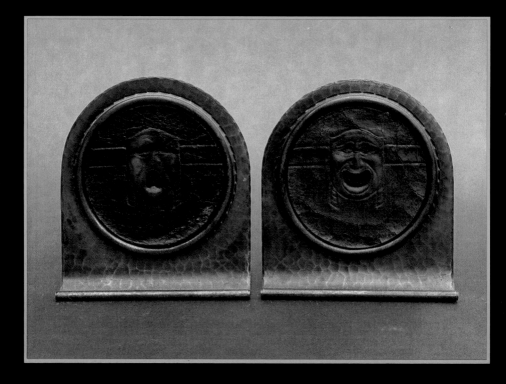

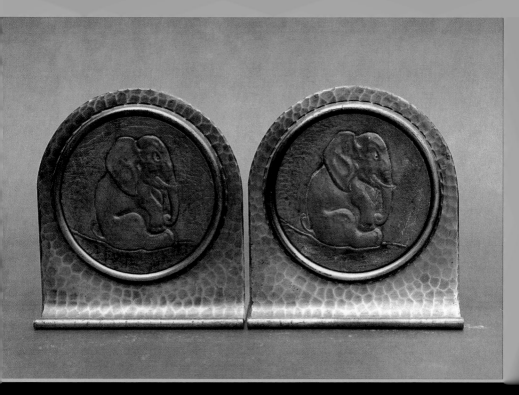

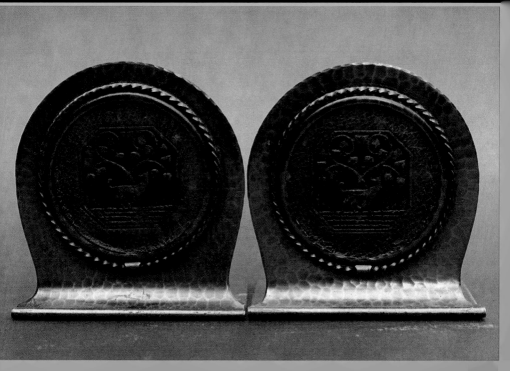

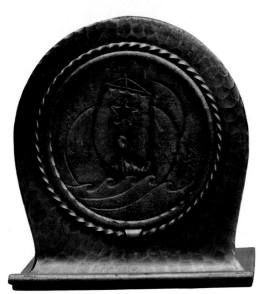

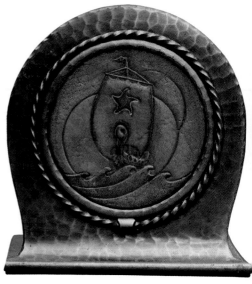

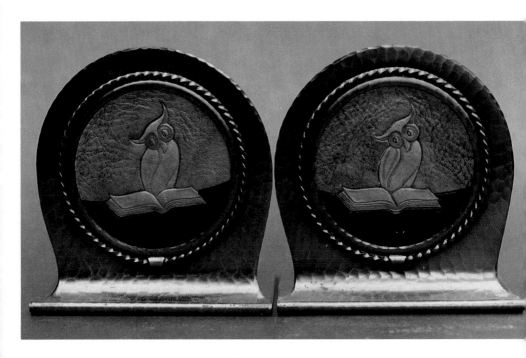

54

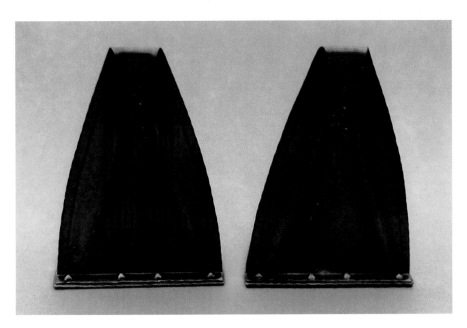

A wonderful pair of early Roycroft bookends which display organic motifs and riveted construction. 5.25" high, 3.75" wide. Early mark. **Current value: $225-$275.**

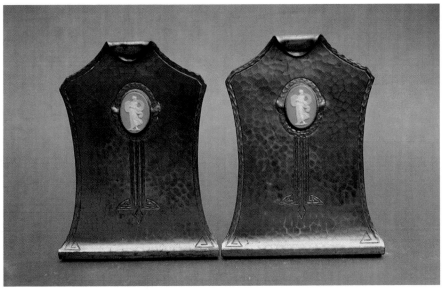

This pair of rarely-seen Roycroft bookends incorporates Wedgwood jasperware medallions into the design. 5" high by 4" wide. Early mark. (Collection of Richard Blacher).
**Production number: 306.**
**Original price: $10/pair (circa 1916).**
**Current value: $250-$350/pair.**

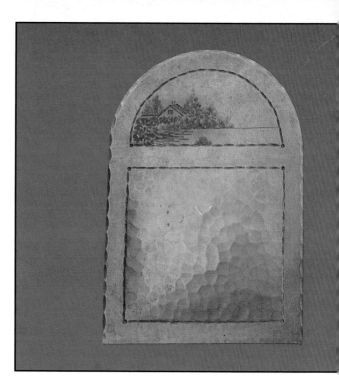

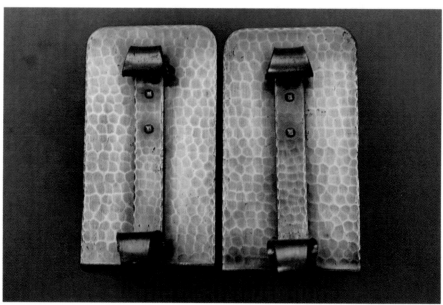

Roycroft bookends made of brass over hammered copper, with rivet-attached scrolled straps. 5.25" high by 2.875" wide. Middle mark. (Collection of Richard Blacher).
**Production number: 353.**
**Original price: $4 (circa 1925).**
**Current value: $175-$225/pair.**

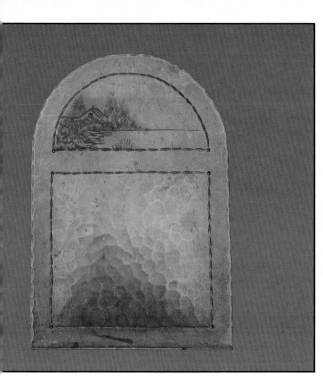

Early Roycroft arch-form book-ends with stitched tooling and finely wrought landscape scene in the upper left of reserve. 6" high, 4.25" wide. Early mark.
**Original price: $3.50 (circa 1910).**
**Current value: $250-$325/ pair.**

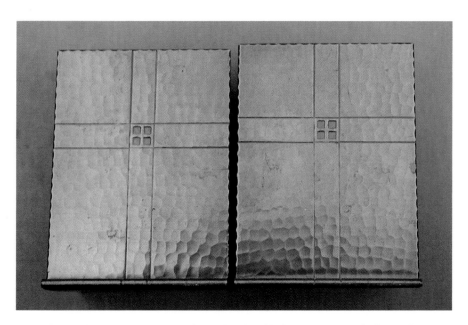

Precisely hammered Roycroft bookends with linear designs. Italian poly-chrome squares and stitched edges. 5" high by 3.75" wide. Middle mark. (Collection of Richard Blacher).
**Current value: $250-$300/pair.**

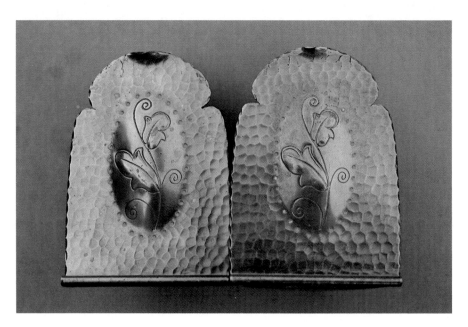

Roycroft hammered copper bookends with tooled organic design in the cen-
ter, framed by Italian polychrome dots. 4.75" high by 3.25" wide. Middle mark.
(Collection of Richard Blacher).
**Current value: $225-$300/pair.**

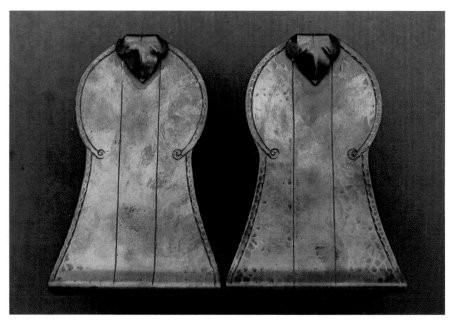

Roycroft keyhole-form bookends with overlapping organic motif at top. Ham-
mered and stitched, with linear tooling. 5.25" high by 3.5" wide. Early mark.
(Collection of Richard Blacher).
**Current value: $175-$225/pair.**

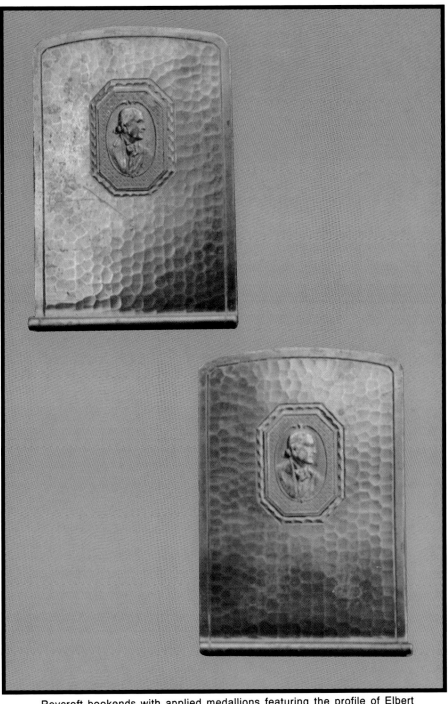

Roycroft bookends with applied medallions featuring the profile of Elbert Hubbard. 4.75" high by 3.25" wide. Middle mark. (Collection of Richard Blacher).
**Current value: $250-$300/pair.**

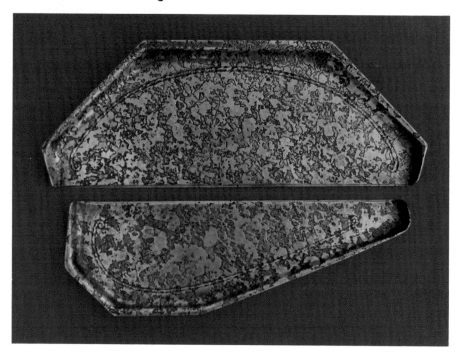

A crumber set consisting of a pair of elongated hexagonal forms with turned edges, tooled scroll designs, deep acid-etched texturing, and Modern Sheffield silver finish. The crumb tray measures 8.5" long by 2.5" wide, while the scraper is 7" long by 2" wide. Late mark.
**Current value: $110-$140.**

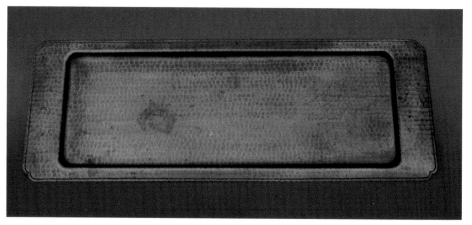

A rectangular serving tray with scalloped corners, recessed interior, and decorative incising around the edges. Brass finish and fine overall hammering. Middle mark.
**Production number: 830.**
**Original price: $8 (circa 1925).**
**Current value: $175-$225.**

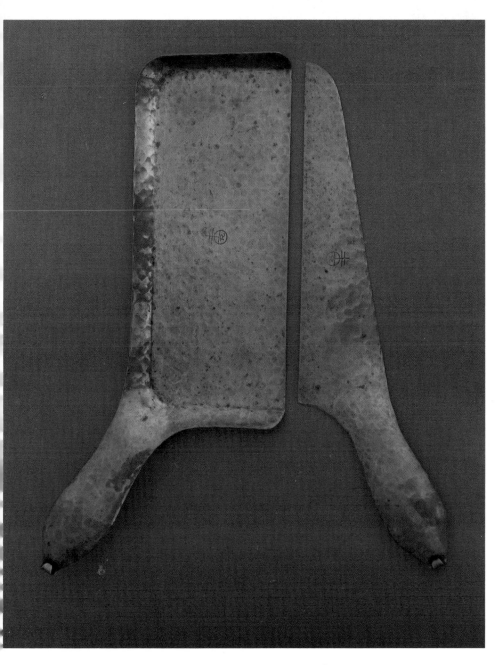

A crumb-tray and scraper which measures 12" long by 5" wide and 11" long by 3.5" wide respectively. This particular set is of early design and workmanship. Note the broad and somewhat crude planishing marks evident on these pieces. Also visible is the early period mark which can be seen on the center of each item.
**Original price: $3 (circa 1910).**
**Current value: $175-$225.**

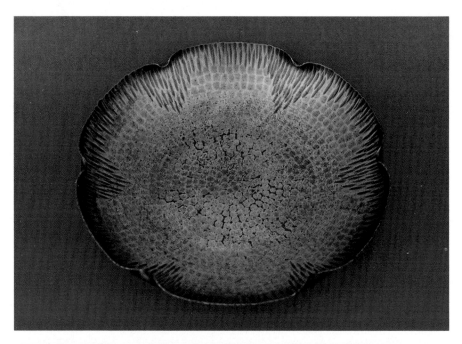

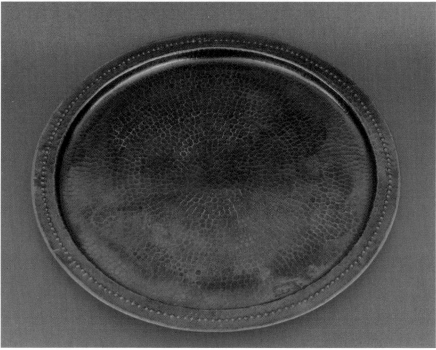

A 16" diameter tray with a recessed interior and a tooled, beaded edge. This tray is distinguished by broad, precise planishing marks and a chocolate brown patina. Middle mark.
**Current value: $300-$400.**

*Opposite page, top:*
A nut or fruit bowl with crimped rim and silver finish. Interiorally hammered with decorative elongated planishing marks. 1.5" high, 9.5" in diameter. Late mark.
**Production number: 251.**
**Original price: $7.50 (circa 1925).**
**Current value: $175-$225.**

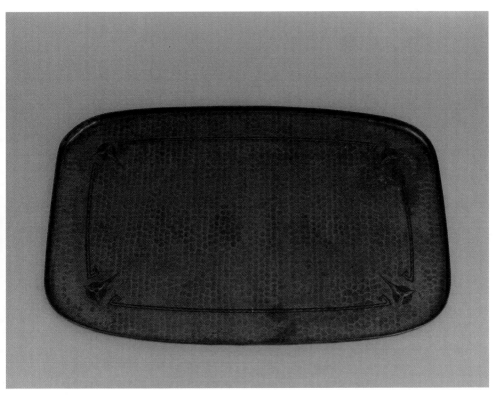

A 9" by 13" rectangular turned-edge tray embellished with tooled geometric and trifoliate designs. Fine workmanship and original patina. Middle mark.
It should be mentioned that although this tray could be purchased and used separately, it was intended as the undertray for a smoker's set which consisted of a matching humidor, cigarette cup, and matchbox holder/ashtray.
**Production number: 611.**
**Original price: $20/four piece set (circa 1916).**
**Current value: Tray: $275-$325.**
      **Four-piece set: $650-$800.**

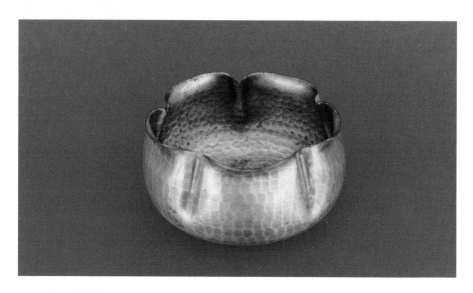

A 2.5" high, 4.5" wide floriform bowl with crimped body and everted rim. The Sheffield Silver finish on this example is in excellent condition. Middle mark. **Current value: $120-$160.**

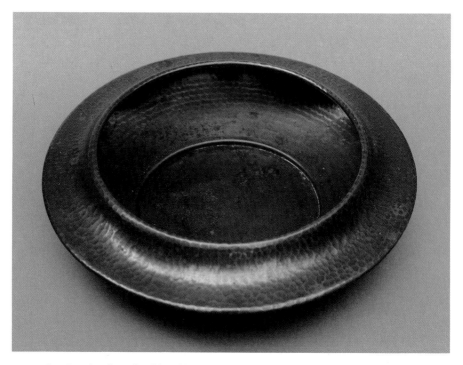

An attractive, low, shouldered bowl made from heavy gauge copper. Brass finish over copper. 2.5" high, 11" in diameter.
**Production number: 240.**
**Original price: $11 (circa 1925).**
**Current value: $250-$350.**

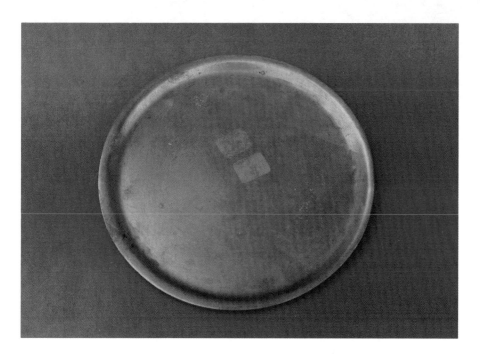

An 8.5" diameter spun copper tray with brass finish. Late and uninteresting, it reflects no craftsmanship. Late mark.
**Current value: $30-$40.**

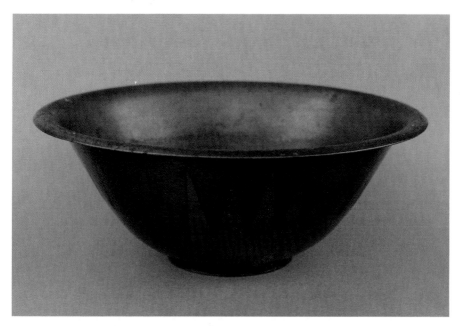

A 4.5" high, 12" diameter Roycroft spun copper bowl with plated brass Art Deco radial designs. Middle mark.
**Current value: $250-$300.**

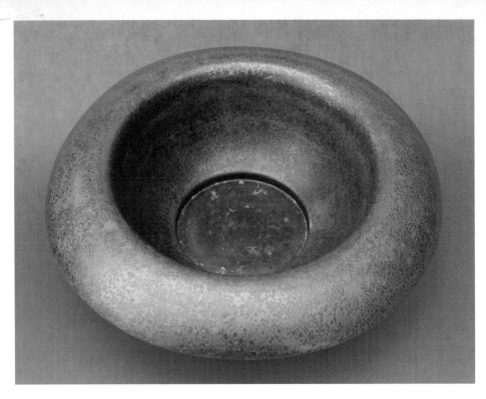

A large rolled-rim bowl with an acid-textured finish. It is 4.5" high and 14.5" in diameter. Late mark.
**Current value: $175-$225.**

An unusual 12" diameter tray with a turned, hammered edge and an interior decorated with an embossed organic motif. Middle mark.
**Current value: $225-$300.**

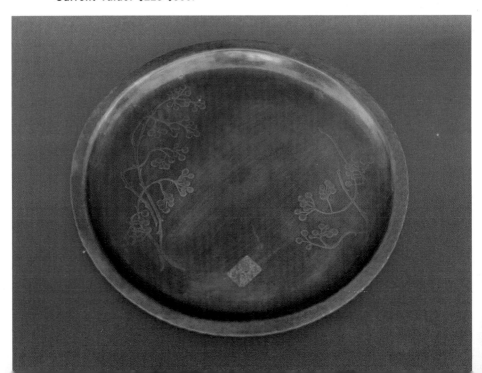

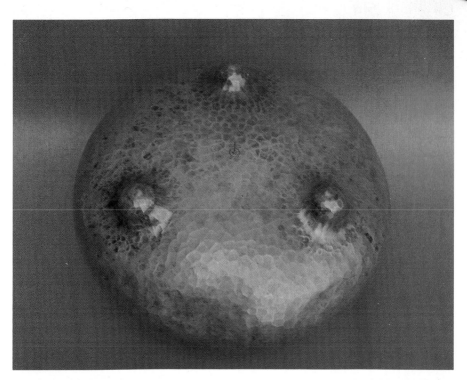

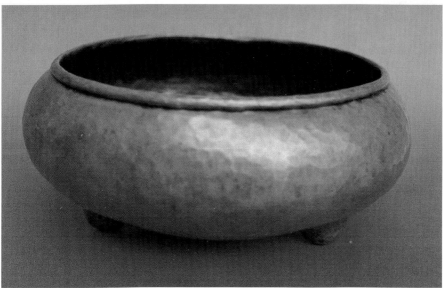

Two views of a circa 1910 fruit or nut bowl notable for its crusty heat patina and its overall, unrefined hand-wrought appearance. Observe that the rim and the feet were formed from the body of the bowl itself rather than from additional pieces of copper. 5.5" high, 10.25" in diameter. Early mark.
**Original price: $5 (circa 1910).**
**Current value: $600-$800.**

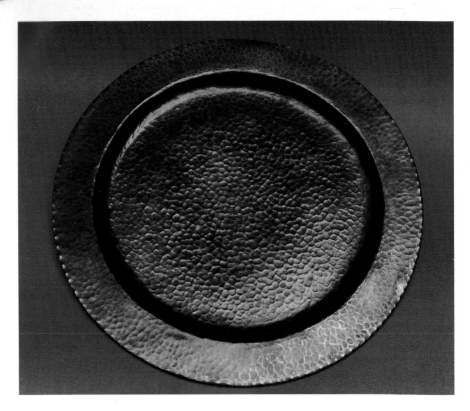

A 12" diameter serving tray somewhat crudely wrought from a sheet of copper. Notice the early Roycroft mark which is visible on the front center of this piece.
**Original price: $3 (circa 1910).**
**Current value: $175-$250.**

*Opposite page, bottom:*
3.75" high by 9" diameter nut or fruit bowl with applied grape design. An early and desirable example of Roycroft workmanship. Silver wash over copper. Early mark. (Collection of Richard Blacher).
**Production number: 803.**
**Original price: $18 (circa 1910).**
**Current value: $800-$1200+**

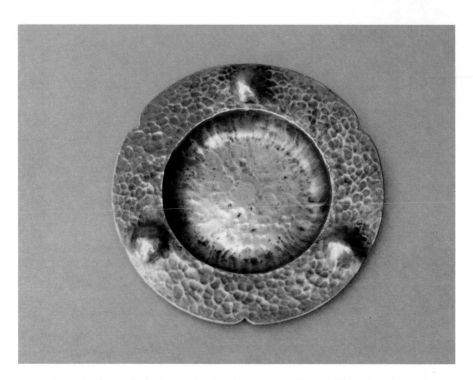

An early Roycroft pin tray with relief-hammered 'blisters'. This piece is very reminiscent of the copperwork produced by Gustav Stickley at the time–no coincidence, since Stickley and Hubbard were unfriendly competitors. Early mark.
**Production number: C-62.**
**Original price: $1.50 (circa 1910).**
**Current value: $100-$150.**

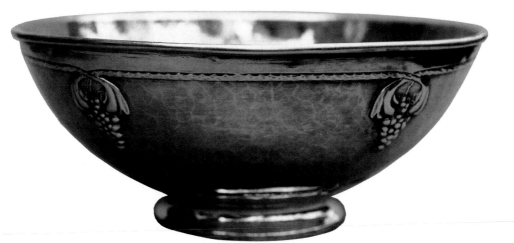

# Desk Items

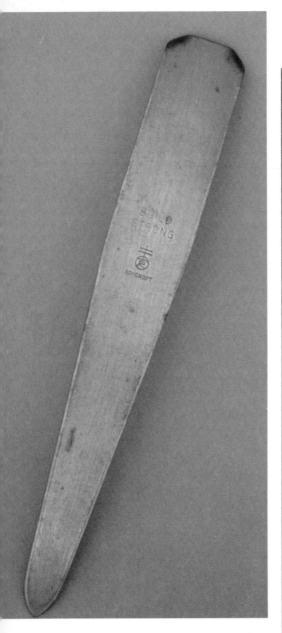

This 'pair' of Roycroft letter openers clearly shows that commissioned items often went unmarked. Case in point: the letter opener on the left bears the 1930 University of Texas logo rather than the standard Roycroft orb and cross mark, which is present on the production letter opener pictured on the right.

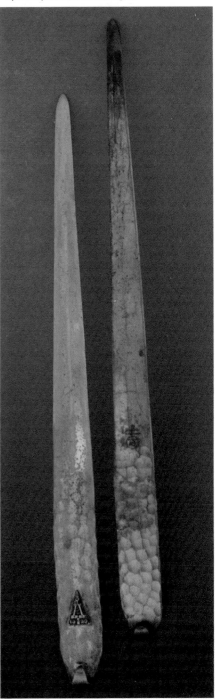

A 7.75" long late period letter opener made from spun and cut copper. Note the impressed words "BUILD STRONG" present above the Roycroft mark; this was one of Elbert Hubbard's favorite mottos.
**Current value: $65-$85.**

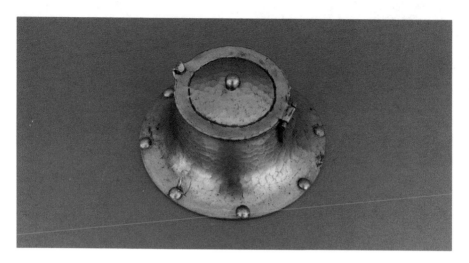

An early and exceptional Roycroft inkwell which displays many of the classic attributes of their circa 1910 production, including a strong design, superb hammering, and riveted construction. 2" high, 3.75" basal diameter. Early mark. This particular inkwell bears a very close resemblance to one made by Gustav Stickley during this time. The question of who came up with the original design first remains a subject of controversy even now.
**Original price: $2 (circa 1910).**
**Current value: $175-$250.**

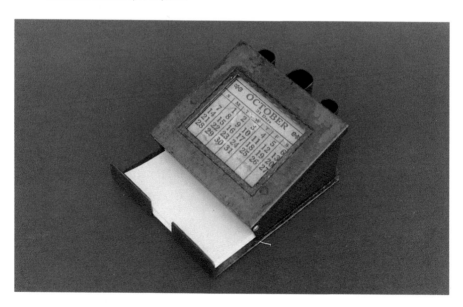

A 2.5" high, 4.5" long rectangular desk unit with attached pen and pencil cylinders, a memo pad slot, and a perpetual calendar which hinges back to reveal a stamp box. Early mark.
**Production number: 512.**
**Original price: $3 (circa 1915).**
**Current value: $150-$225.**

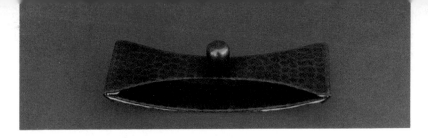

A 4.75" long bow-shaped rocker blotter with attached knob. Middle mark.
**Production number: 556.**
**Original price: $1.70 (circa 1915).**
**Current value: $75-$95.**

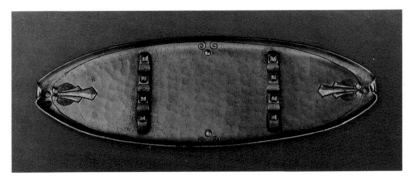

An 8.5" long, 3" wide oval pen tray embellished with trifoliate forms and incised linework. A pleasing design and crisp, detailed workmanship highlight this Roycroft desk piece. Middle mark.
**Production number: 706.**
**Original price: $2.50 (circa 1916).**
**Current value: $120-$150.**

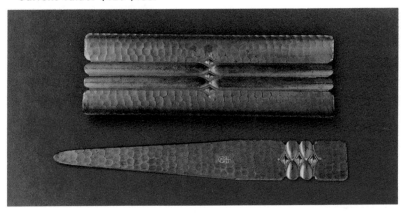

A two-piece Roycroft desk set comprised of an 8" long letter opener and a 6.75" long, 2.25" wide pen tray. Both are distinguished by good hammering and a pleasing geometric line and diamond design. Middle mark.
**Production number: 730.**
**Original price: $22 (circa 1925) for a complete five piece desk set, which included an inkwell, a letter rack, and a set of blotter corners in addition to the two items shown here.**
**Current value: $125-$175 for both items.**

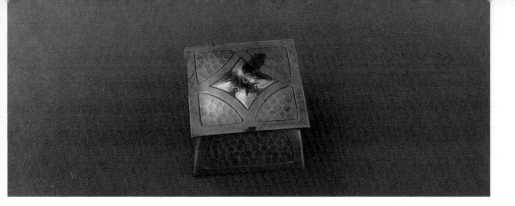

A Roycroft inkwell with tooled floriform on the lid. This item is 1.75" high and 2.75" square. Brass on copper finish. Middle mark.
**Current value: $110-$150.**

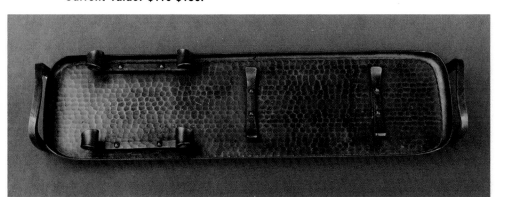

A 14.5" long, 3.75" wide inkwell/pen tray unit. Crisp planishing marks, a dark patina, and decorative/functional riveting combine to distinguish this piece. Middle mark.
**Production number: 719.**
**Original price: $20.**
**Current value: $200-$275 (with inkwell).**

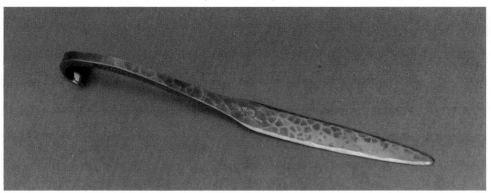

An 8" long hammered copper letter opener with a scrolled handle and a flared, bevelled blade. Middle mark.
**Current value: $65-$85.**

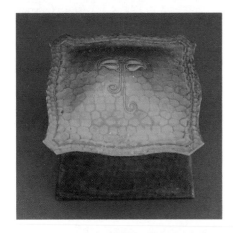

A beautifully hammered Roycroft inkwell with a scalloped-edge lid embellished with linear tooling and a trifoliate design. Middle mark. **Current value: $125-$175.**

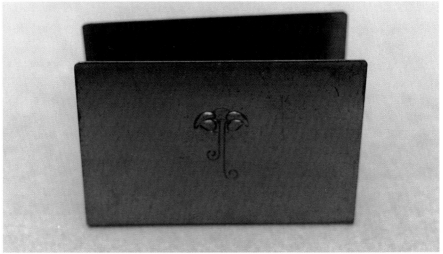

A late period Roycroft letter rack simply made from a single sheet of smooth copper, with a tooled organic device decorating the front. 3.25" high, 4.875" long. Late mark.
**Current value: $75-$95.**

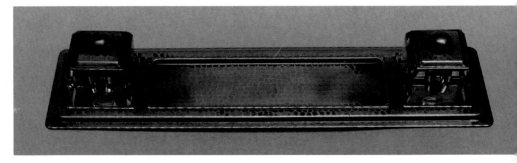

A Roycroft double inkwell/pen tray with unmarked Steuben crystal wells. It is 2.75" high, 15" long, and 3.75" wide. Middle mark.
**Current value: $300-$400.**

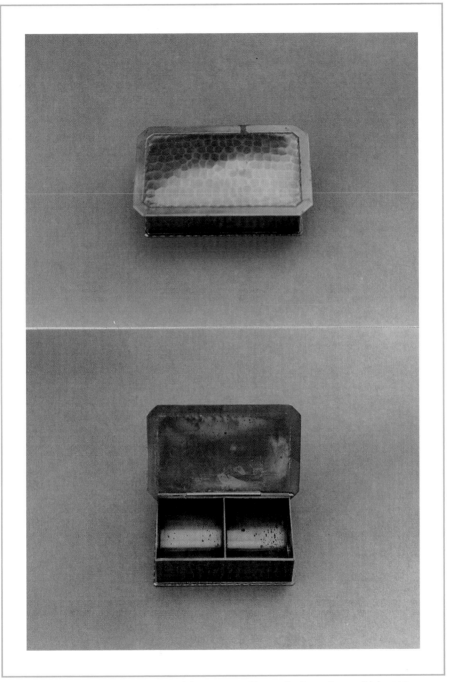

Shown both open and closed is a scarce Roycroft stamp box, which measures 1.25" high, 4" long, and 2.5" wide. The cut corners, stitched linework, and precise hammering are typical of mid-period Copper Shop production. Middle mark.
**Current value: $150-$200.**

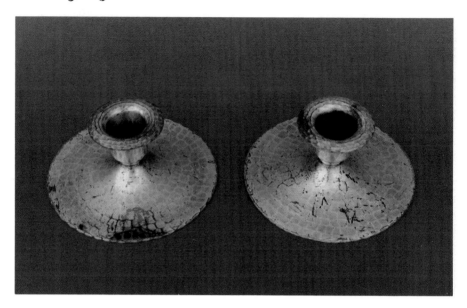

A pair of silver-plated candlesticks with broad circular bases, surmounted by deep candle sockets with finely hammered rims. 1.75" high, 4" basal diameter. Late mark.
**Production number: 426.**
**Original price: $6.50/pair (circa 1925).**
**Current value: $110-$150/pair.**

A single candlestick with a deep socket of spun copper, a wide rolled rim bobeche, and a flared foot. The surface is acid-etched and brass-plated. Late mark.
**Current value: $45-$75.**

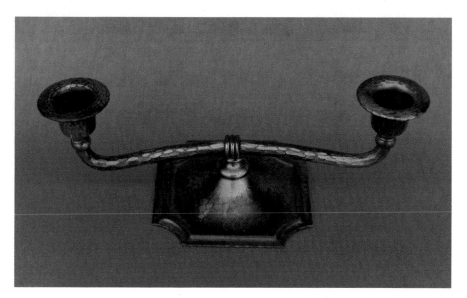

A two-branch candelabra with a square base embellished with bevelled edges and cut corners, which supports an undulating arm with attached candle sockets. Brass finish over copper. 3" high. 9.5" long. Middle mark.
**Production number: 432.**
**Original price: $6.25 (circa 1925).**
**Current value: $165-$195.**

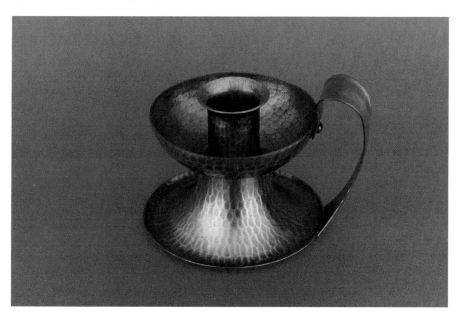

A Roycroft chamberstick which is both well-designed and well-executed. Of note are the precise, consistent planishing marks and the riveted handle. Old Brass finish over copper. 3.25" high, 4.5" greatest width. Middle mark.
**Original price: $3 (circa 1915).**
**Current value: $150-$225.**

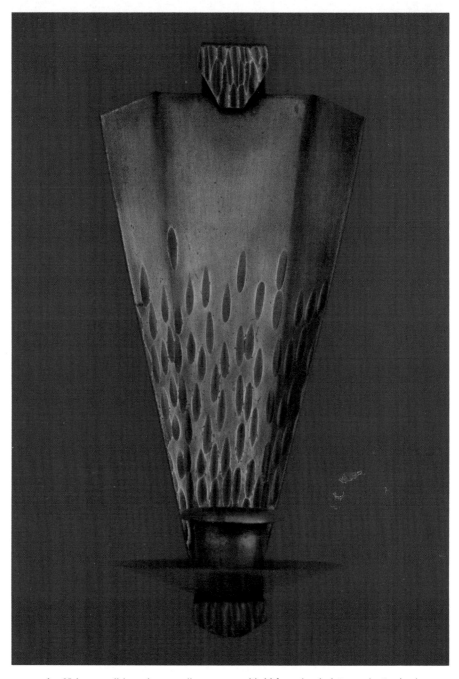

An 8" long wall-hanging candle sconce with V-form backplate and attached bobeche and candle socket. Broad radial hammering and brass finish. Late mark.
**Production number: 434.**
**Original price: $3.50 (circa 1925).**
**Current value: $125-$175.**

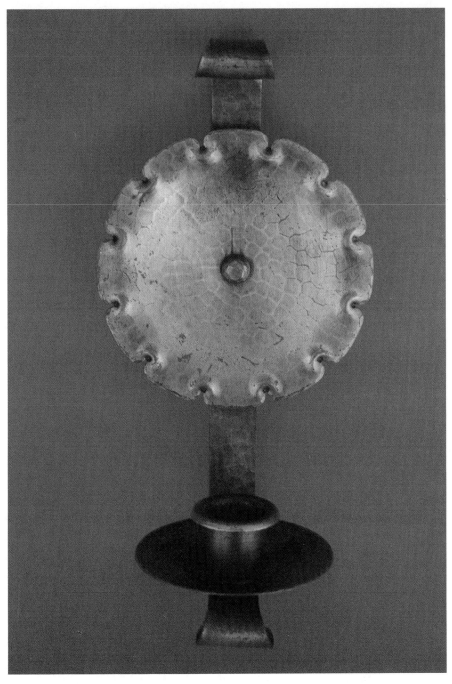

A wall-hanging candle sconce consisting of a wrought backplate with rivet-attached floriform reflector and deep candle socket. 8" long. Late mark.
**Production number: 435.**
**Original price: $5 (circa 1925).**
**Current value: $150-$190.**

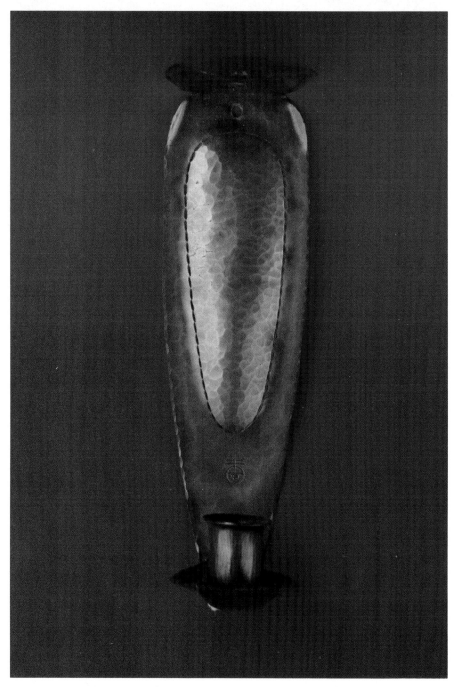

A 9.5" long wall sconce made of wrought copper, with attached candle cup, inverted arrow head-form backplate, and attached smoke shield. Early mark.
**Production number: 402.**
**Original price: $2.50 (circa 1910).**
**Current value: $175-$250.**

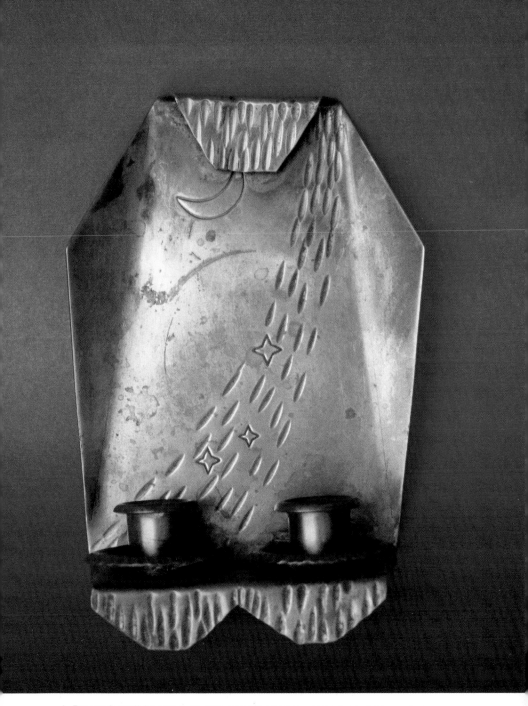

A Roycroft wall-hanging double candle sconce made from heavy gauge brass-plated copper. The tooled moon and stars motif on the backplate are a possibly unique variation. 8" long, 5.75" wide. Late mark.

**Production number: 439.**
**Original price: $7.50 (circa 1925).**
**Current value: $150-$200.**

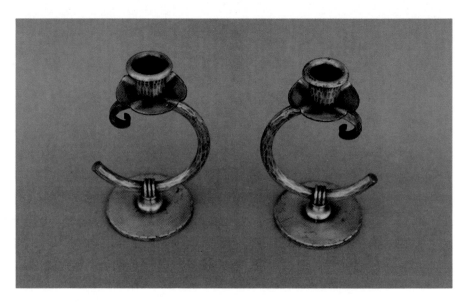

A pair of late period candlesticks which are particularly well-made, in heavy silver-plated copper. They consist of thick, round bases with C-form shafts and attached candle sockets and crimped bobeches. Late mark.
**Current value: $300-$375.**

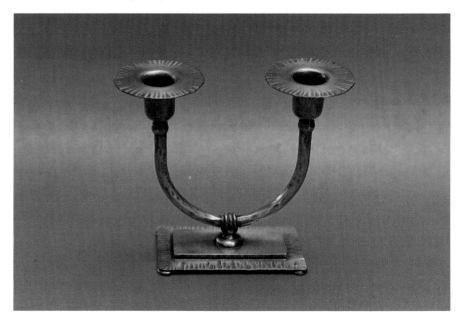

A Roycroft two-branch candlestick broadly hammered from heavy copper stock. It is 6" high, and the base is 4.5" long by 2.75" wide. Brass finish over copper. Late mark.
**Production number: 437.**
**Original price: $17.50/pair (circa 1925).**
**Current value: $200-$275/pair.**

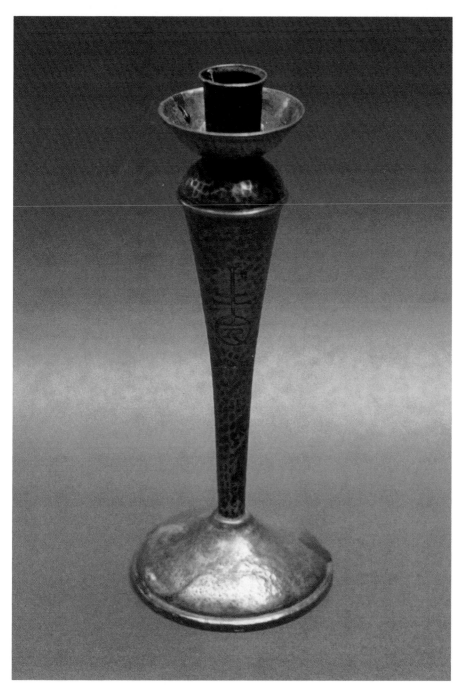

A rare early Roycroft candlestick embellished with a large incised orb and cross symbol on the shaft. This unusual candlestick is made from silver-plated wrought copper and is 8.5" high with a basal diameter of 3.25". The base is hollow and is weighted with oak. This candlestick was probably made for the Roycroft Inn. **Current value: $400-$600.**

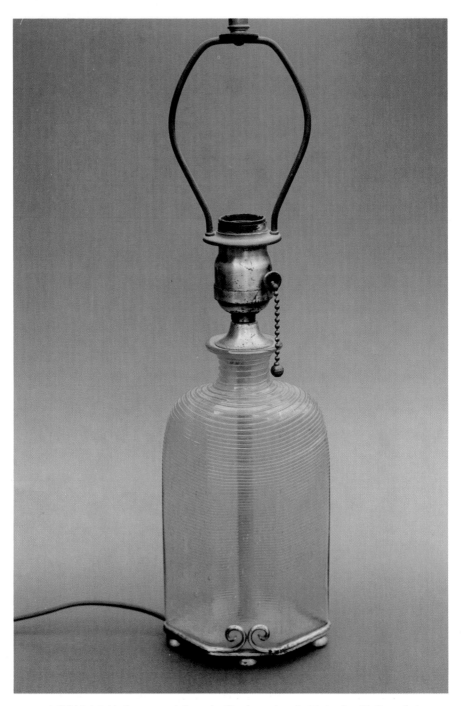

A 17" high table lamp consisting of a Steuben glass bottle body with threaded decoration and internal controlled bubbles. The metal fittings are of silverplated Roycroft copper. Middle mark. (Collection of Richard Blacher).
**Current value: $1200-$1400.**

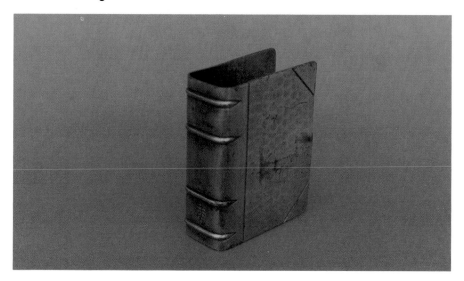

A rectangular cigarette pack holder in the form of a miniature book, complete with incised binding and hammered cover. 3" high, 2.5" long, 1" wide. Middle mark.
**Production number: 661.**
**Original price: $2.50 (circa 1925).**
**Current value: $100-$140.**

A 3-in-1 Roycroft smoking unit comprised of a cigarette pack holder, matchbox holder, and ashtray. 4" high, 4.5" greatest diameter. Middle mark.
**Production number: 647.**
**Original price: $4.50 (circa 1915).**
**Current value: $110-$150.**

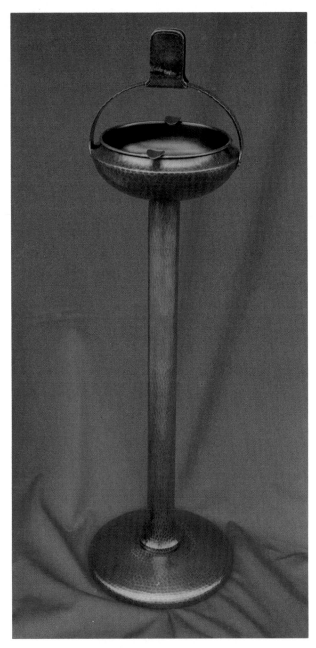

A 29" high hammered copper smoker's stand consisting of an 8" diameter circular base which supports a long tubular shaft surmounted by an ashtray and an arching matchbox holder. Although collectors find smoking accessories undesirable, this ashtray stand remains an exception due to the impressive size and workmanship. Middle mark.

**Production number: 621.**
**Original price: $12.**
**Current value: $600-$800.**

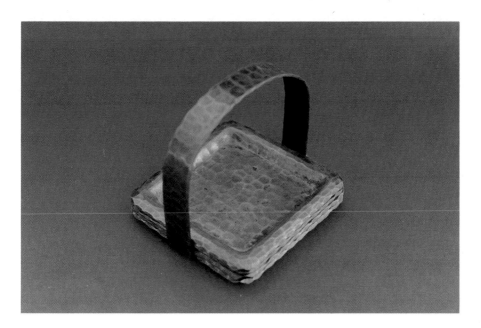

A nest of four ashtrays with an arch-form handled caddy. 2.5" high, 2.75" square. Middle mark.
**Production number: 643.**
**Original price: $4 (circa 1925).**
**Current value: $70-$85.**

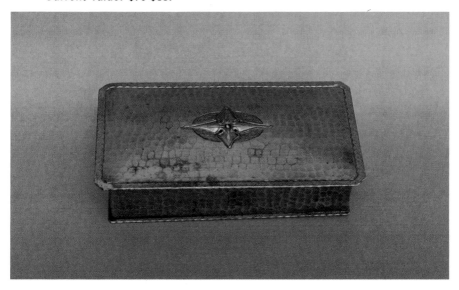

A Roycroft cigarette box with a slightly domed lid embellished with a floral design, stitched edges and cut corners. This piece exhibits fine overall craftsmanship. It is 1.75" high, 3.75" wide, and 7.25" long. Middle mark.
**Production number: 610.**
**Original price: $6 (circa 1916).**
**Current value: $250-$300.**

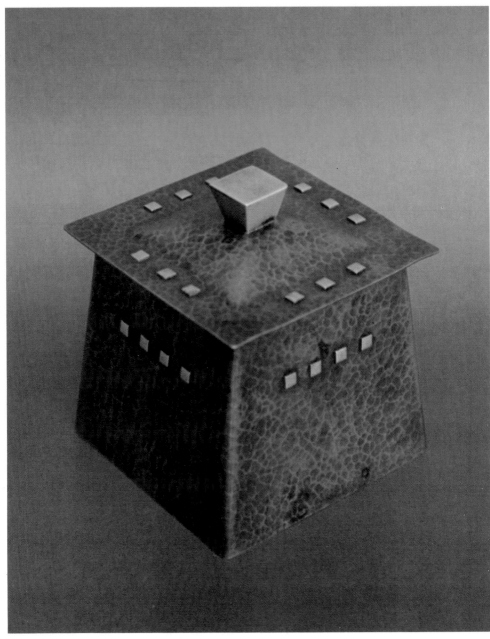

Easily one of the great Roycroft rarities is this slant-sided humidor decorated with nickel silver squares. This early, much-sought-after piece represents one of Karl Kipp's and Dard Hunter's classic collaborations. In terms of design, it owes a great deal to the Vienna Secession movement of Austria, where Hunter studied in 1908 and 1909. This humidor is 6" high and 5.25" square at the base. Early mark.
**Original price: $9 (circa 1910).**
**Current value: $2000-$3000+.**

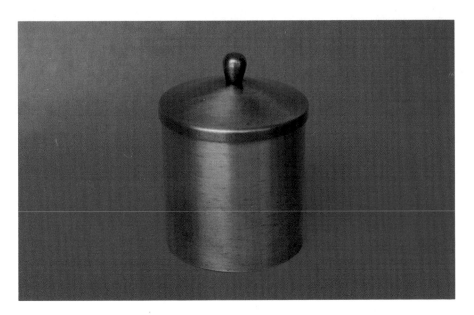

A 4.25" high, 3" diameter spun copper humidor exhibiting little or no hammering and poor patination, typical of Roycroft's post-Depression production. Late mark.
**Current value: $40-$60.**

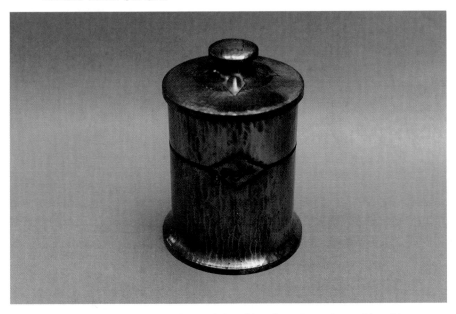

A 7" high, 4.75" diameter Roycroft humidor. Superb workmanship with a tooled floriform on the lid and an incised band on the body incorporating a personalized diamond-shaped medallion with the name "Dold." Early mark.
**Production number: A variation of C-601 E.**
**Original price: $10 (circa 1910).**
**Current value: $300-$400 (unpolished).**

A rare three-piece smoking set consisting of an oval tray with turned ends and tooled interior edges (13.5" long by 5.75" wide), a footed ash bowl (1.5" high by 3.25" wide), and a spectacular lidded humidor with a riveted band and attached triangular ring handles (6" high by 6.5" wide). Early mark.

This set is extremely unusual in that it represents somewhat of a Roycroft oddity. While the design and the markings of this set are circa 1910, the acid-texturing and silver wash are indicative of late '20s/early '30s Copper Shop production. Given the above observations, it seems likely that this set was leftover stock from 1910 which was later revised to meet the tastes of the time.

**Current value: $600-$800.**

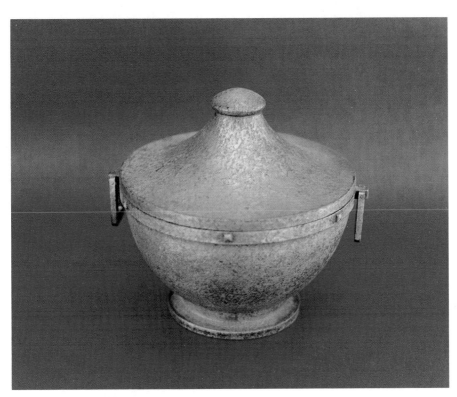

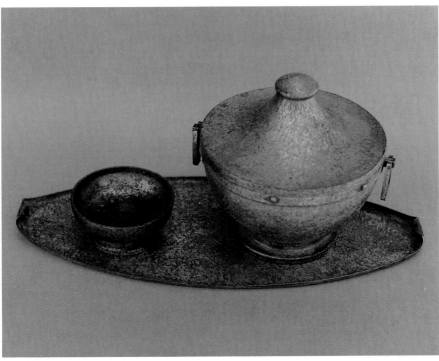

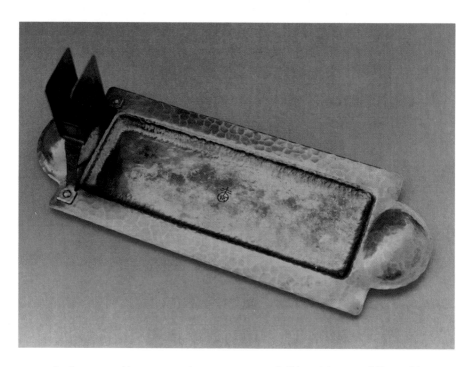

As far as smoking accessories are concerned, this set is one of Roycroft's better efforts. The rivets and relief-hammered 'blisters' are paradigmatic of the Copper Shop's early workmanship. This smoker's set originally held three squares of cut glass which functioned as cigar jars and an ashtray–see the accompanying illustration. 4.5" high, 12" long, and 4.75" wide. Early mark.
**Original price: $5 (circa 1910).**
**Current value: $250-$350.**

Price, $5.00

SMOKER'S-SET

Length of base, 12 inches

Depth of ash-receiver, 1¾ inches

All the glass parts of these smoking-sets are the finest cut glass.
They can be removed for cleaning.

The complete smoker's set as it appeared in a circa 1910 Roycroft catalog.

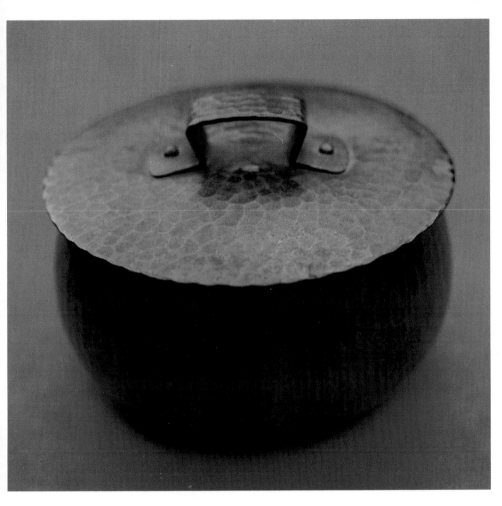

A nicely made Roycroft humidor (or 'tobacco bowl', as it was marketed). 3.25" high, 4.5" in diameter. Middle mark. (Collection of Richard Blacher).
**Production number: 635.**
**Original price: $8 (circa 1925).**
**Current value: $250-$350.**

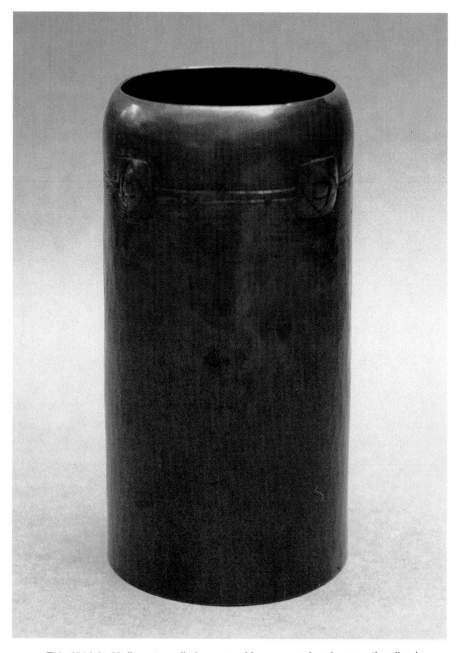

This 6" high, 3" diameter cylinder vase with repoussed and conventionalized rose and thorn motif is an exceptional (and elusive) example of early Roycroft design and workmanship. Early mark.
**Original price: $4 (circa 1910).**
**Current value: $600-$800+.**

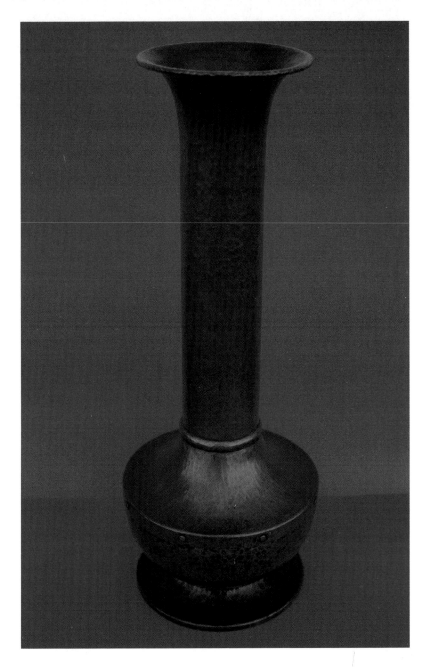

The American Beauty vase is rightly considered to be a hallmark of Roycroft design and workmanship. Made in four different sizes (7", 12", 19", and 22" high), it displays both beautiful hammering and patina. This particular size (22" high) is the rarest, made in limited quantities for the Grove Park Inn of Asheville, North Carolina.

**Production number: 201 (19" example).**
**Original price: $10 (circa 1910).**
**Current value: $1500-$2000.**

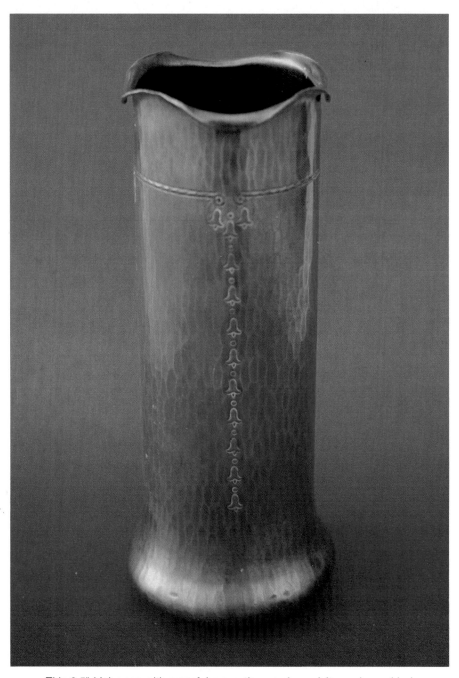

This 9.5" high vase with graceful proportions and exquisite workmanship is representative of one of the Roycrofters' best efforts. Note the bellflower designs as well as the precision of the hammering. Middle mark.

**Production number: 213.**
**Original price: $9 (circa 1916).**
**Current value: $500-$700.**

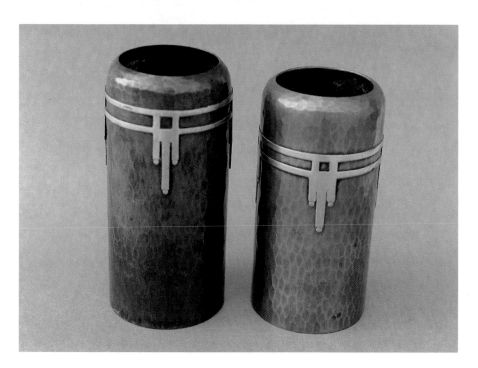

These two early vases clearly illustrate the great deal of variation encountered in the Roycrofters' handmade copper wares. The vase on the left is 6.5" high, while the one on the right is 6" high. Also note the differing placement of the German silver overlays as well as the variance in the overlays themselves.
**Production number: 203.**
**Original price: $5 (circa 1916).**
**Current value: $600-$800+ each.**

A late period Roycroft vase of flared cylindrical form, made from a thin gauge of spun, acid-etched copper. 4.5" high, 6" greatest diameter. Late mark.
**Current value: $150-$225.**

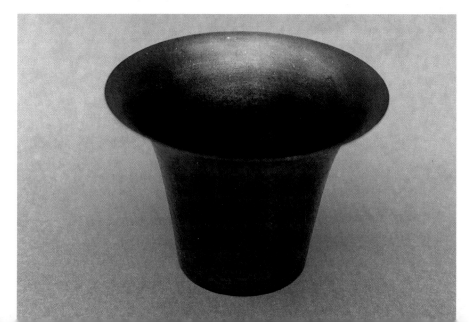

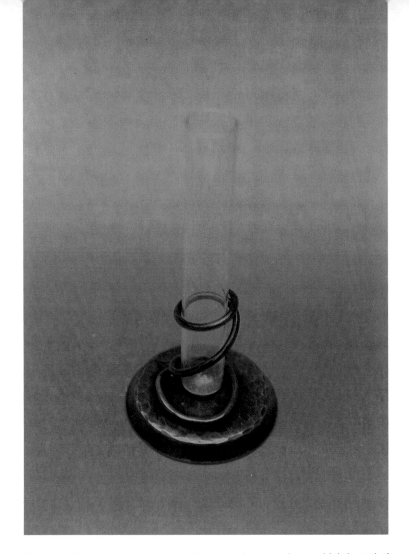

This early bud vase has a circular hammered copper base which is embellished with a tooled leaf design, from which extends a copper wire 'vine' that supports the glass insert. Like so many of the Roycroft Copper Shop's early designs, this bud vase is simple, attractive, and ultimately functional. 2.75" basal diameter, 6.25" overall height. Early mark.
**Production number: 103.**
**Original price: 75 cents (circa 1916).**
**Current value: $150-$200.**

*Opposite page:*
This rare Roycroft shaft vase abundantly displays the skill of the early Copper Shop craftsmen. It is thought by many that large, unusual Roycroft vases such as this one were discontinued in favor of the more popular (and more common) American Beauty vase. 15" high. Early mark.
**Original price: $7 (circa 1910).**
**Current value: $2000-$2500.**

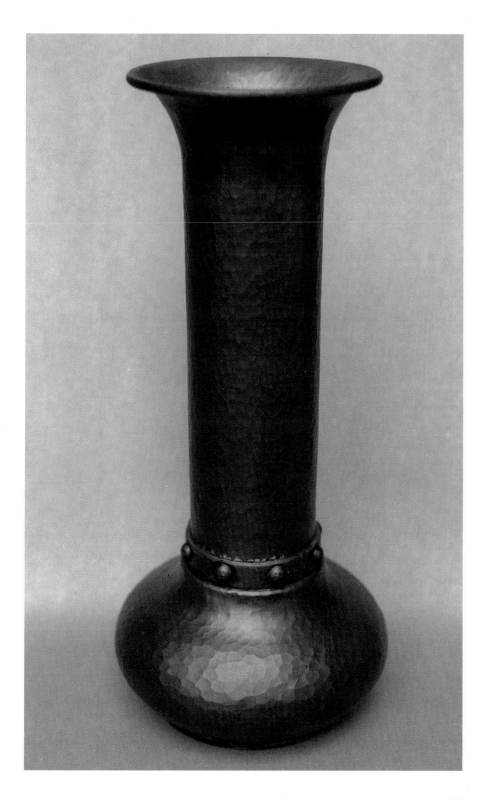

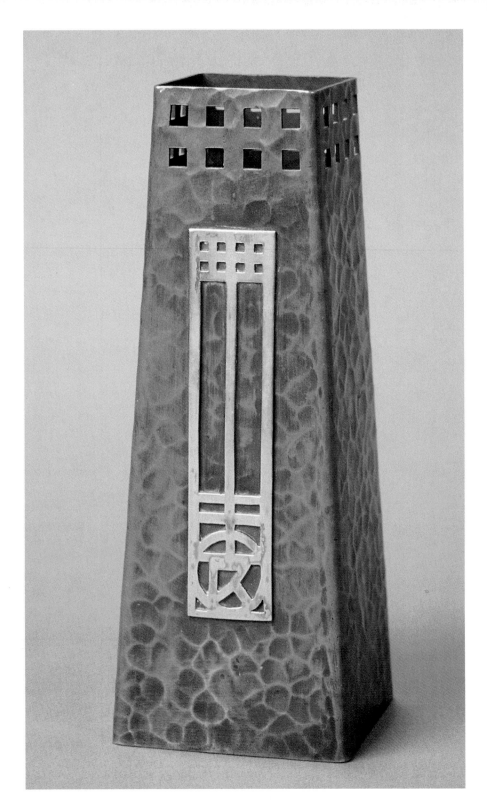

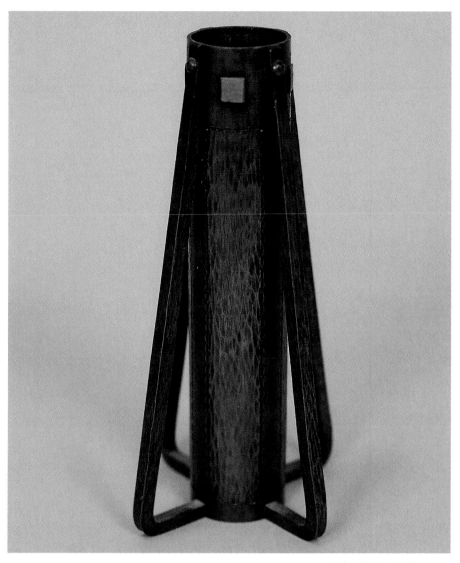

Originally marketed by the Roycrofters as an 'Egyptian flower-holder' this item is now commonly known as a buttress vase due to the four angular handles. This fine and early vase is further distinguished by elongated wood-grain hammering, four nickel-silver squares near the rim, and riveted construction. This vase is 8" high, 4.25" at its greatest diameter, and bears the early mark. (Photograph courtesy of David Rago, Trenton).
**Original price: $5 (circa 1910).**
**Current value: $2000-$2500.**

*Opposite page:*
One of the rarest and most desirable examples of Roycroft art metal is this 6.75" high vase with square cut-outs and a nickel-silver overlay of the orb and cross mark. It was also made without the German silver overlay. Early mark. (Photo courtesy of David Rago, Trenton).
**Original price: $7 (circa 1910).**
**Current value: $6000+.**

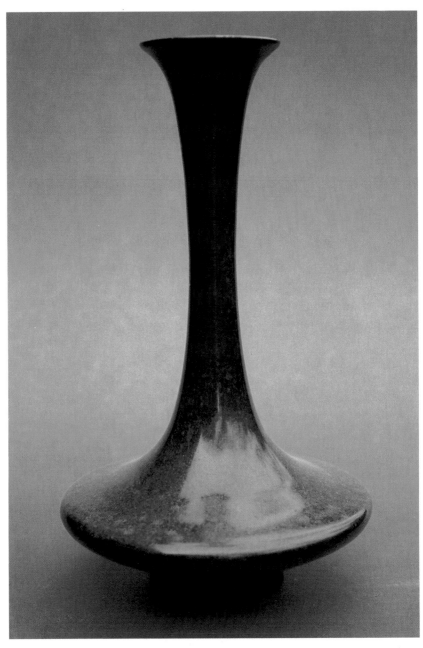

A Japanesque-style Roycroft vase with a flattened body, elongated and flaring neck, and an Etruscan finish. This is one of the rarest Roycroft vase forms. 9.5" high. (Collection of Richard Blacher).
**Production number: 241.**
**Current value: $1000-$1500.**

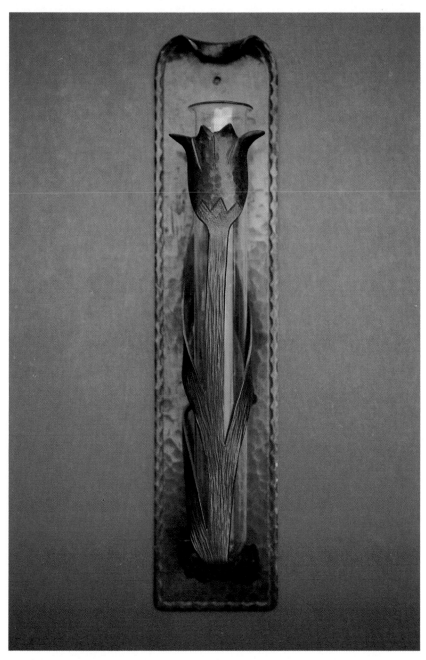

An exceptional Roycroft wall-hanging bud vase. Hammered and stitched backplate with an attached undulating tulip-form fitter for the glass insert. Green Italian polychrome highlighting. 10.25" long by 2.25" wide. Unmarked, but certainly of circa 1910 Copper Shop production. (Collection of Richard Blacher).
**Current value: $250-$350+.**

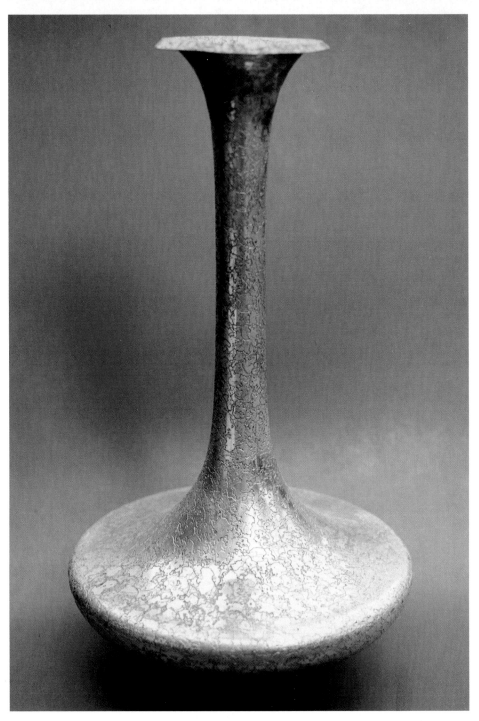

A later incarnation of the Roycroft Japanesque vase. This variation has an acid-etched finish and a silver wash over copper. 16" high, 9" at its greatest diameter. Middle mark. (Collection of Richard Blacher).
**Current value: $800-$1200.**

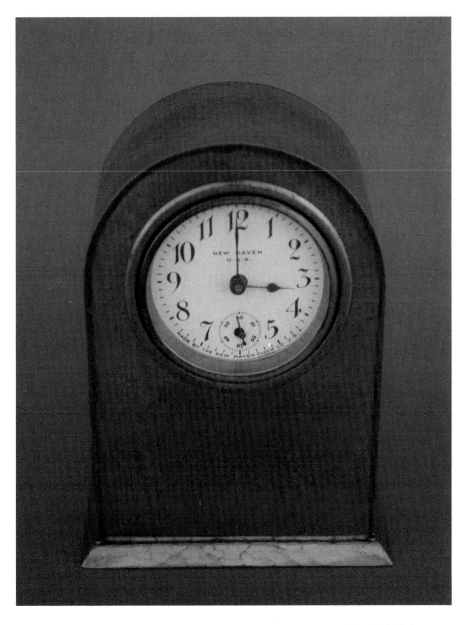

One of the rarest Roycroft copper items is this desk or boudoir clock. It is 4.75" high, 3.5" wide and is constructed of four pieces of meticulously hammered copper (front, back, base, and shell) which are held together with almost invisible seams of solder. The clock works is by New Haven. Early mark.
**Production number: 1102.**
**Original price: $6 (circa 1910).**
**Current value: $700-$850+.**

Although incidental in terms of design and workmanship, this Roycroft hatpin is nonetheless a very difficult item to locate. The pin itself is 10.5" long, while the wrought, silver-plated top is 1" in diameter. Middle mark.
**Original price: 50 cents.**
**Current value: $200-$300.**

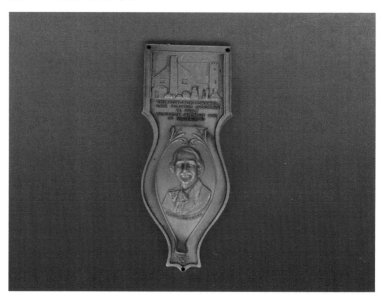

A rare Roycroft door knocker made of bronze. In a December 1930 advertisement in *The Roycrofter* magazine, it is described as follows: "Souvenir of Elbert Hubbard's birthday celebration. This souvenir was especially gotten-up for those who were unable to attend the Birthday Celebration held here last June. It is a bronze Door Knocker—a reproduction of the Roycroft Chapel and the head of Elbert Hubbard. Size: 1.5" wide by 3.5" long. Priced at $2, postage paid."

Interestingly enough, the back of this piece bears the maker's mark of the Robbins Company of Attleboro, Massachusetts, who was apparently subcontracted to make this item for the Roycrofters.
**Current value: $135-$185.**

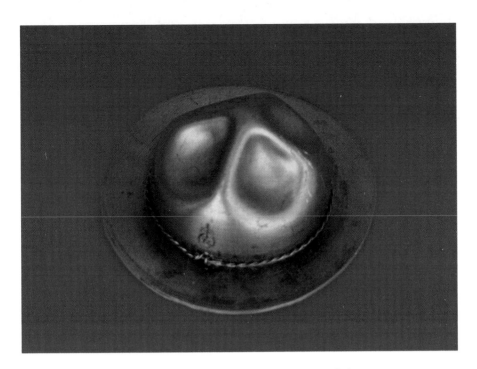

Yet another rare and unusual Roycroft item is this tooled copper paper-weight–a facsimile of the hat worn by Elbert Hubbard. It is 1.25" high and 3.25" in diameter. Early mark.
**Current value: $125-$165.**

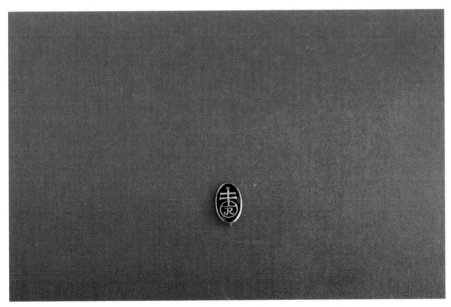

A rare 14K gold and black enamel Roycroft lapel pin. .75" long, .5" wide.
**Current value: $150-$200.**

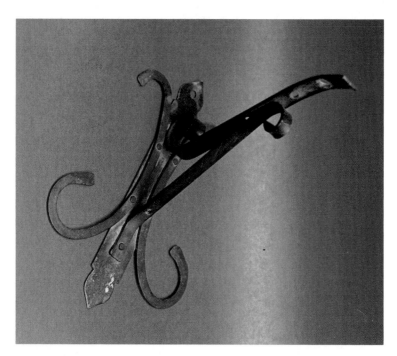

This bracket represents a rare example of Roycroft wrought iron. It is especially rare as it is marked with the orb and cross symbol. Most Roycroft iron items went unmarked, making them almost impossible to identify. This bracket is 10" long and 9" wide.
**Current value: $200-$300+.**

A large Roycroft acid-textured picture frame measuring 12" high by 10" wide. Brass wash over copper. Late mark.
**Production number: 1116.**
**Original price: $30 (circa 1925).**
**Current value: $200-$275.**

A 3" long napkin clip formed from a strip of silver-plated copper, which exhibits broad hammer marks along the edges. Late mark.
**Production number: A variation of 835.**
**Original price: $1 (circa 1925).**
**Current value: $75-$110.**

A 6.5" high, 4.25" wide acid-etched Roycroft picture frame. Roycroft frames are difficult to locate. Late mark.
**Production number: 1118.**
**Original price: $18 (circa 1925).**
**Current value: $150-$200.**

This Roycroft incense burner is an odd, hard-to-find item, which exhibits a surprisingly complicated design for its small size. (3.5" high by 3" diameter). Middle mark.
**Current value: $125-$150.**

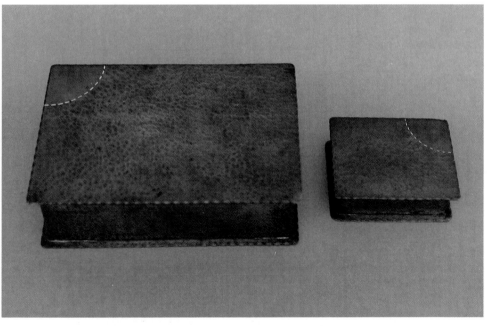

A set of early Roycroft boxes with stitched corner designs and small, exacting hammering. Note the precision of the workmanship around the edges of the lids and bases. Roycroft copper boxes in general (and these in particular) are difficult to locate. The large box is 7.5" long by 5" wide by 2.25" high, while the smaller one is 3.75" long by 3" wide by 1.25" high. Early mark on both pieces.
**Current value: $400-$550/set.**

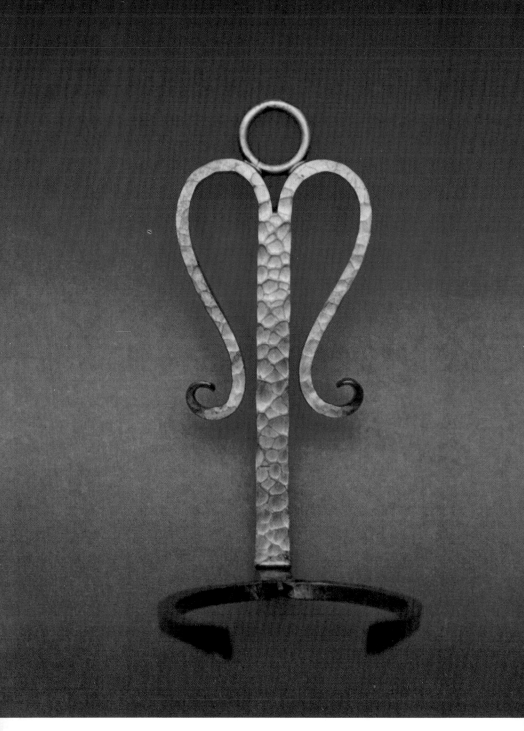

A wall-hanging potted plant holder made from a single strip of hammered copper, which was split at both ends and then tooled into shape. 7.25" long. Late mark.
**Current value: $125-$175.**

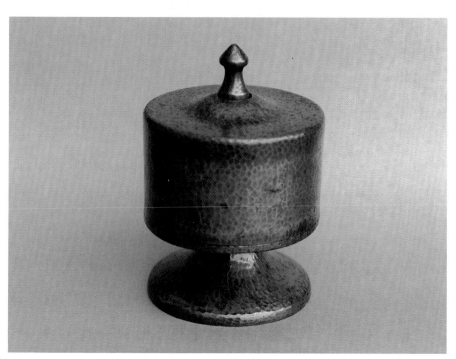

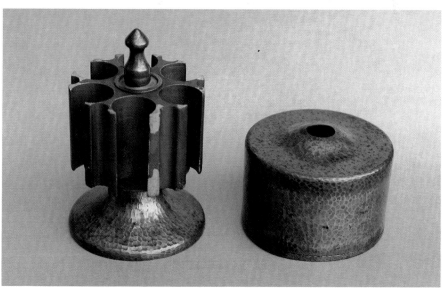

The elusive Roycroft poker chip holder, shown with and without its cover. The chip caddy is cast zinc, supported on a rod by the hammered copper base and surmounted by a spun copper finial. The hammered copper hood then fits snugly over the chip unit, resting atop it. 7" high, 4.5" greatest diameter. Middle mark.

**Production number: 1109.**
**Current value: $400-$600.**

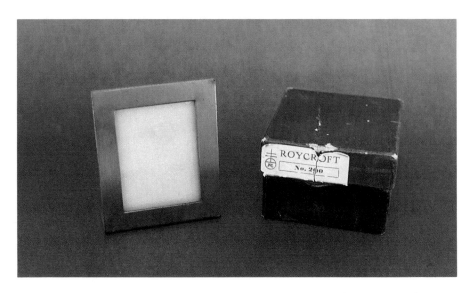

A small Roycroft picture frame (3.5" high by 2.75" wide) shown with its rarely-seen original box. Late mark.
**Production number: 200.**
**Current value: $95-$135.**

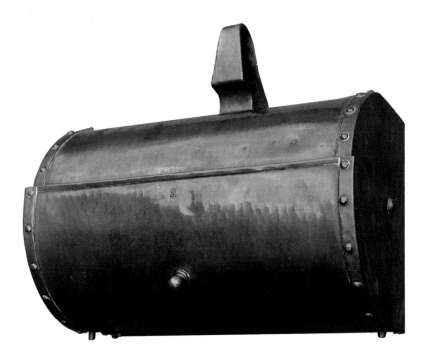

What could possibly be rarer than this Roycroft bun warmer? Hammered copper with prominent riveted construction and brass fittings. 5.5" high, 11.5" wide, and 10.5" deep. Middle mark. (Collection of Richard Blacher).
**Current value: $1500-$2000+.**

# Original Advertisements

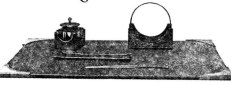
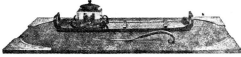

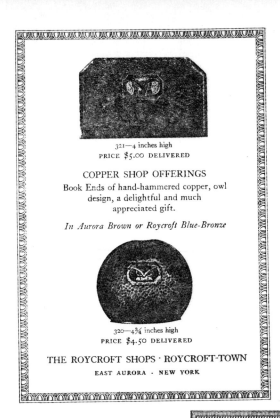

321—4 inches high
PRICE $5.00 DELIVERED

## COPPER SHOP OFFERINGS

Book Ends of hand-hammered copper, owl
design, a delightful and much
appreciated gift.

*In Aurora Brown or Roycroft Blue-Bronze*

320—4¾ inches high
PRICE $4.50 DELIVERED

## THE ROYCROFT SHOPS · ROYCROFT-TOWN

EAST AURORA · NEW YORK

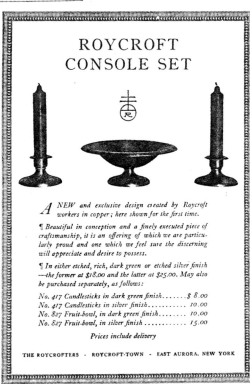

# ROYCROFT
# CONSOLE SET

*A NEW and exclusive design created by Roycroft workers in copper; here shown for the first time.*

¶ *Beautiful in conception and a finely executed piece of craftsmanship, it is an offering of which we are particularly proud and one which we feel sure the discerning will appreciate and desire to possess.*

¶ *In either etched, rich, dark green or etched silver finish —the former at $18.00 and the latter at $25.00. May also be purchased separately, as follows:*

No. 417 Candlesticks in dark green finish.......$ 8.00
No. 417 Candlesticks in silver finish...........10.00
No. 827 Fruit-bowl, in dark green finish........10.00
No. 827 Fruit-bowl, in silver finish............15.00

*Prices include delivery*

THE ROYCROFTERS · ROYCROFT-TOWN · EAST AURORA, NEW YORK

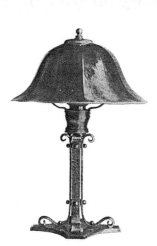

*No. 913: Roycroft Hand-Hammered Copper*

¶ A beautiful piece of craftsmanship. The shade is craft-finish heavy glass—a rich golden amber color. Gives a soft, mellow light. Copper parts are a warm, antique brown color. ¶ Lamp 16 in. high; shade 10 in. diam. . . **$30.50.***

*Price includes war tax and transportation charges

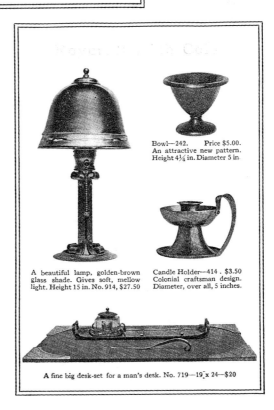

Bowl—242. Price $5.00. An attractive new pattern. Height 4¼ in. Diameter 5 in.

A beautiful lamp, golden-brown glass shade. Gives soft, mellow light. Height 15 in. No. 914, $27.50

Candle Holder—414 . $3.50 Colonial craftsman design. Diameter, over all, 5 inches.

A fine big desk-set for a man's desk. No. 719—19 x 24—$20

# 𝕽𝖔𝖞𝖈𝖗𝖔𝖋𝖙 𝕳𝖆𝖓𝖉𝖒𝖆𝖉𝖊 𝕮𝖔𝖕𝖕𝖊𝖗

Roycroft Copper is made to endure always. Time will mellow it, and the hands of many generations may leave their marks on its surface, but the thing itself is indestructible. ¶ The crude rough sheet of copper is hammered and shaped over stakes and anvils. Patiently, blow by blow, the beautiful object is formed. A Skilled Designer plans the piece, a Master Craftsman makes it. ¶ All the wonderful copper tones are enriched and brought out. For contrast, and to emphasize the high lights, there is a suggestion of bronze-green in the shadows ‿ ‿ ‿

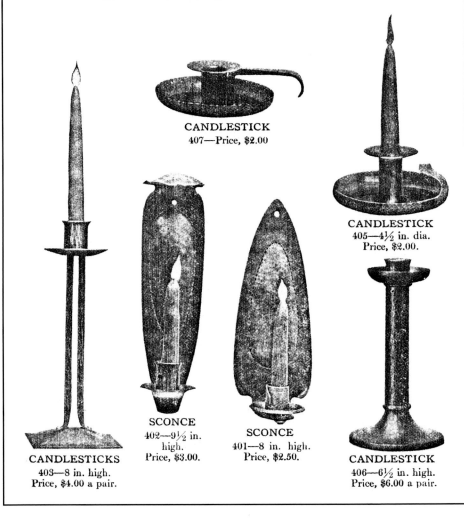

CANDLESTICK
407—Price, $2.00

CANDLESTICK
405—4½ in. dia.
Price, $2.00.

CANDLESTICKS
403—8 in. high.
Price, $4.00 a pair.

SCONCE
402—9½ in.
high.
Price, $3.00.

SCONCE
401—8 in. high.
Price, $2.50.

CANDLESTICK
406—6½ in. high.
Price, $6.00 a pair.

**SERVING-TRAY**
815—22 in. long.   Price, $10.00.

**TEA-BELL**
816—Price, $2.00

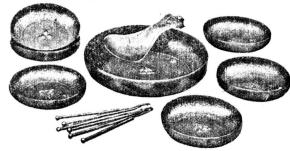

**NUT-SET**
801—Price, $12.00

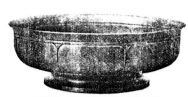

**NUT OR FRUIT BOWL**
810—9 in. dia.   Price, $10.00.

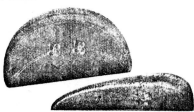

**CRUMB-TRAY AND SCRAPER**
802—Price, $3.00

**NUT-SET**
809—Price, $8.00

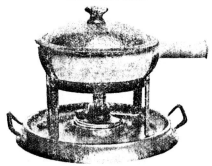

**CHAFING-DISH**
817—Price, $16.00

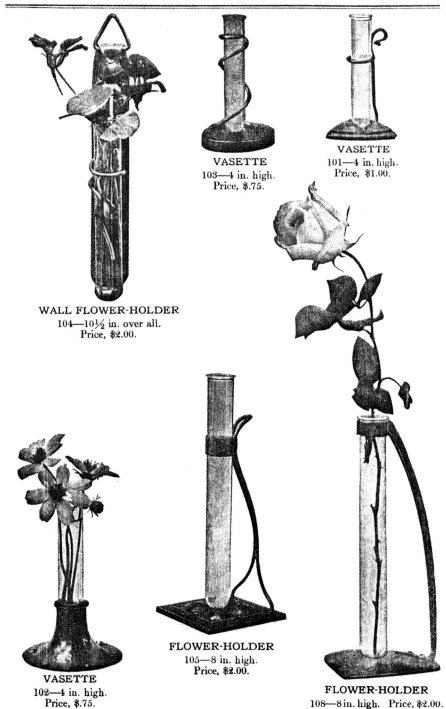

**VASETTE**
103—4 in. high.
Price, $.75.

**VASETTE**
101—4 in. high.
Price, $1.00.

**WALL FLOWER-HOLDER**
104—10½ in. over all.
Price, $2.00.

**VASETTE**
102—4 in. high.
Price, $.75.

**FLOWER-HOLDER**
105—8 in. high.
Price, $2.00.

**FLOWER-HOLDER**
108—8 in. high.   Price, $2.00.

**BOWL**
214—4 in. dia.
Price, $2.50.

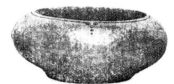

**BOWL**
216—7 in. dia.   Price, $4.00.

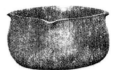

**BOWL**
215—4 in. dia.
Price, $2.50.

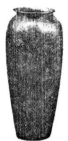

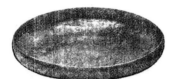

**TURNED-EDGE TRAY**
207—5 in. dia.   Price, $1.00.

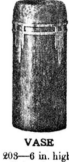

**VASE**
205—6 in high.
Price, $7.50.

**VASE**
203—6 in. high.
Price, $5.00.

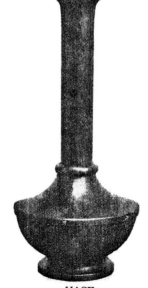

**VASE**
201—19 in. high.   Price, $15.00.
210—12 in. high.   Price, 10.00.
211— 7 in. high.   Price,   5.00.

**VASE**
212—10 in. high.
Price, $10.00.

**VASE**
213—9½ in. high.
Price, $9.00.

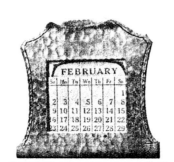

CALENDAR—504.   Price $1.00.

PAPER-KNIFE—507.   Price, $.75.

PAPER-KNIFE—508.   Price, $.50.

NEWSPAPER-HOLDER
510—Price, $1.50

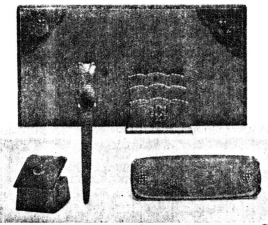

704

**DESK-PAD**
Price, $10.00

**INK-POT**
Price, $6.00

**STATIONERY-HOLDER**
Price, $5.50

**PEN-TRAY**
Price, $4.50

**PAPER-KNIFE**
Price, $2.00

**COMPLETE**
Price, $28.00

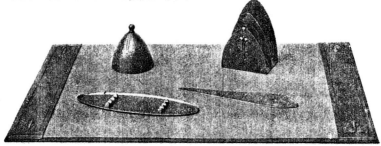

| | | | | |
|---|---|---|---|---|
| DESK-PAD | 706. Price, $ 8.00 | PEN-TRAY | 706. Price, $ 2.50 |
| INK-POT | " " 4.50 | PAPER-KNIFE | " " 1.50 |
| STATIONERY-HOLDER | " " 3.50 | COMPLETE | " " 20.00 |

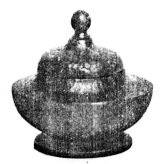

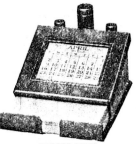

**INK-POT**
513—Price, $4.00

**DESK-SET**
512—Pen and Pencil Holder,
Calendar, Memo-Pad
and Stamp-Box.
Price, $3.00.

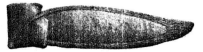

**LETTER-OPENER—**511.  Price, $.75.

**PEN-TRAY—**505.  Price, $2.00.

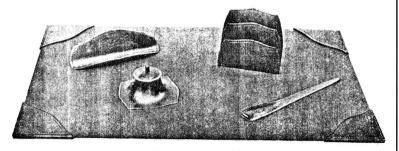

**DESK-SET—701**

| Desk-Pad | | | $4.00 | Pen-Tray | | | $ 1.00 |
|---|---|---|---|---|---|---|---|
| Ink-Pot | | | 3.00 | Paper-Knife | | | 1.00 |
| Stationery-Holder | | | 3.00 | Complete | | | 12.00 |

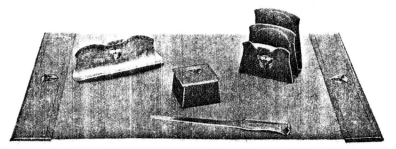

**DESK-SET—703**

| Desk-Pad | | | $7.50 | Pen-Tray | | | $ 2.00 |
|---|---|---|---|---|---|---|---|
| Ink-Pot | | | 3.50 | Paper-Knife | | | 1.50 |
| Stationery-Holder | | | 3.50 | Complete | | | 18.00 |

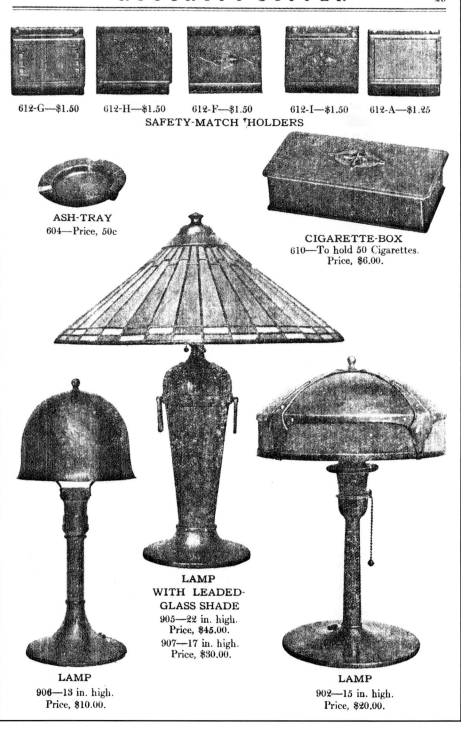

612-G—$1.50    612-H—$1.50    612-F—$1.50    612-I—$1.50    612-A—$1.25

**SAFETY-MATCH HOLDERS**

**ASH-TRAY**
604—Price, 50c

**CIGARETTE-BOX**
610—To hold 50 Cigarettes.
Price, $6.00.

**LAMP**
**WITH LEADED-**
**GLASS SHADE**
905—22 in. high.
Price, $45.00.
907—17 in. high.
Price, $30.00.

**LAMP**
906—13 in. high.
Price, $10.00.

**LAMP**
902—15 in. high.
Price, $20.00.

**SAFETY-MATCH HOLDER**
618-F—With 4 Nested
Ash-Trays. Price. $4.00.

**MATCH-HOLDER**
607—With Nested
Ash-Trays.
Price, $3.50.

**PIPE-KNOCKER**
617—7 in. dia.
Price, $2.50.

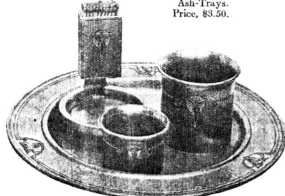

SMOKERS' SET—615.  Price, $12.00.
Same Set Plain—Price, $9.00.

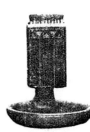

**MATCH-HOLDER**
608—With Nested
Ash-Trays.
Price, $3.50.

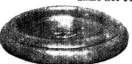

**NESTED ASH-TRAY**
614-A—Price, $3.00.

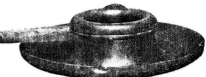

**PIPE-KNOCKER**
618—7 in. dia.  Price, $4.00.

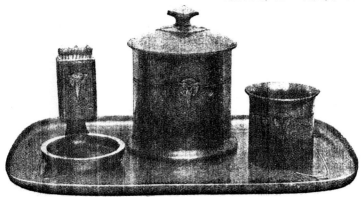

SMOKERS' SET—611.  Price $20.00.  Same Set Plain—$15.00.

CARD-TRAY
1003-B—6 inches.
Price, $2.00.

CARD-TRAY
1001-A—6 inches.
Price, $2.50.

CARD-TRAY
1003-A—6 inches.
Price, $2.50.

CARD-TRAY
1000-C—6 inches diameter.
Price, $2.00.

CARD-TRAY
1002-A— 7 inches long.
Price, $3.00.

CARD-TRAY
1002-B—7 inches long.
Price, $2.00.

CARD-TRAY
1000-A—6 inches diameter.
Price, $1.50.

CARD-TRAY
1000-E—6 inches diameter.
Price, $2.50.

CARD-TRAY
1000-B—6 inches diameter
Price, $1.50.

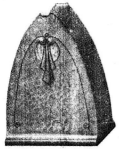

**BOOK-ENDS**
308—5 in. high.
Price, $3.00.

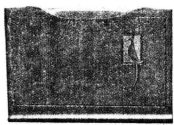

**BOOK-ENDS**
307—4 in. high.   Price, $4.00.

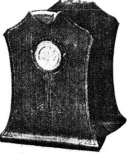

**BOOK-ENDS**
306—5 in. high.
Wedgwood Medallions
Price, $10.00.

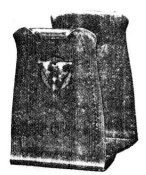

**BOOK-ENDS**
301—5 in. high.   Price, $3.00.

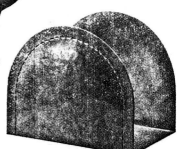

**BOOK-ENDS**
302—3½ in. high.   Price, $2.00.

**BOOK-ENDS**
304—4½ in. high.   Price, $3.50.

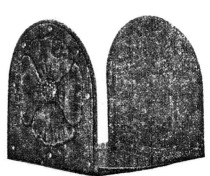

**BOOK-ENDS**
305—5½ in. high.   Price, $4.50.

# Selected Bibliography

Gray, Stephen, ed. *A Catalog of the Roycrofters* (catalog reprint). New York, Turn of the Century Editions, 1989.

*Grove Park Inn Arts & Crafts Conference Catalog* (periodical). Bruce Johnson, publisher. Asheville, NC: Knock on Wood Publications, 1992.

Hamilton, Charles F., *Roycroft Collectibles.* New York: A.S. Barnes and Co., 1980.

Johnson, Bruce, *The Official Identification and Price Guide to Arts and Crafts.* New York: House of Collectibles, 1988.

*Karl Kipp.* Tookay Shop catalog: 1914 (catalog reprint). East Aurora, NY: Roycroft Arts Museum, 1992.

Levulis, Stanley and Dorothy, *The Story of Elbert Hubbard and the Roycrofters of East Aurora.* New York: Stanley and Dorothy Levulis, 1971.

Ludwig, Coy L. *The Arts and Crafts Movement in New York State* 1890s-1920s. Layton, Utah: Peregrine Smith, 1983.

Shay, Felix, *Elbert Hubbard of East Aurora.* New York: Wm.H. Wise & Co., 1926.

*Tookay.* Tookay Shop catalog: 1912 (catalog reprint). East Aurora, NY: Roycroft Arts Museum, 1992.